MW00620710

IMAGES
of America

THE JEWISH COMMUNITY
OF SAVANNAH

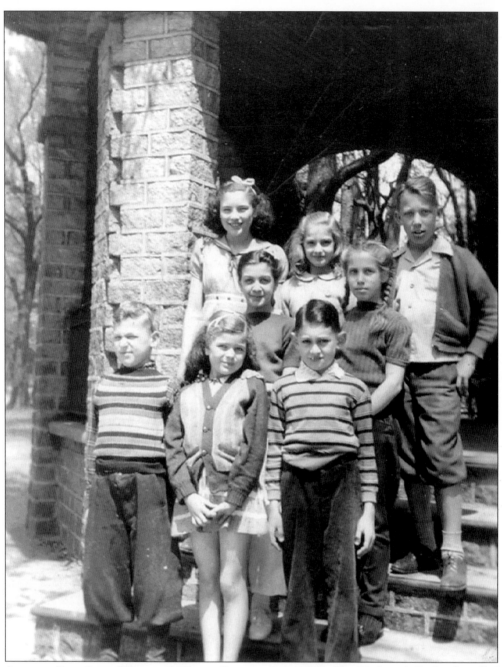

ARBEITER RING SHULE/WORKMEN'S CIRCLE SCHOOL, APRIL 1942. The Workmen's Circle, also called the Arbeiter Ring, was formed around the turn of the 20th century to foster Jewish identity through the promotion of culture, education, friendship, and justice. The school, photographed here by the teacher, Mr. Rossi, on a field trip, was operated by the organization. The school featured a Yiddish class where the children learned to read, write, and perform plays in the Yiddish language. It was a purely secular school that stressed culture and the history of European Jews. From left to right are (front row) Phillip Dunn, Barbara Dunn, and Leonard Kantziper; (middle row) Norma (Grablow) Pike and Gertrude (Hoffman) Hackman; (back row) Gerri Dunn, Shirley (Galkin) Diamond, and Philip Hoffman.

IMAGES
of America

THE JEWISH COMMUNITY
OF SAVANNAH

Valerie Frey and Kaye Kole

ARCADIA

Copyright © 2002 by Valerie Frey and Kaye Kole.
ISBN 0-7385-1449-7

Published by Arcadia Publishing,
an imprint of Tempus Publishing, Inc.
2 Cumberland Street
Charleston, SC 29401

Printed in Great Britain.

Library of Congress Catalog Card Number: 2002104615

For all general information contact Arcadia Publishing at:
Telephone 843-853-2070
Fax 843-853-0044
E-Mail sales@arcadiapublishing.com

For customer service and orders:
Toll-Free 1-888-313-2665

Visit us on the internet at http://www.arcadiapublishing.com

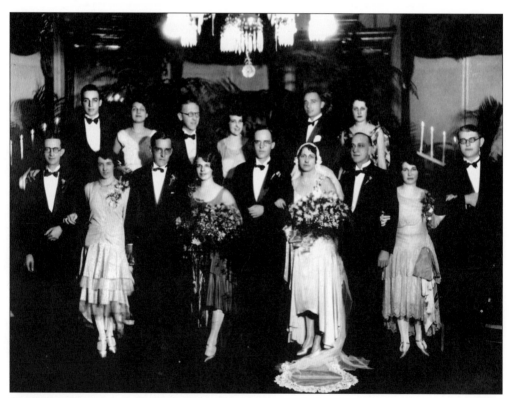

GLASSBERG WEDDING, 7 OCTOBER 1929. This wedding took place in the Gold Room of the DeSoto Hotel. Pictured from left to right are (front row) Sims Gaynor (nee Guckenheimer), Dora (Gittelsohn) Gaynor, Myron Glassberg, Jean (Guckenheimer) Guthman, Bert Glassberg, Helen (Dub) Glassberg, Jacob Dub, Juliet "Judy" (Frank) Kuhr, and Raymond "Bus" Kuhr; (back row) Walter Guthman, Jane (Kohler) Strauss, Meyer Collat, Josephine (Hirsch) Cranman, Semon Eisenberg, and Josephine (Wachtel) Smith.

CONTENTS

ACKNOWLEDGMENTS

We wish to thank the staff of the Georgia Historical Society for all of their help and advice, in addition to the use of their facilities. We express our special appreciation to Marc Belanger, the archives assistant of the Jewish Archives, who has made many useful collections available to the public. Additional thanks go to the dozens of people in the Jewish community who gave us original photographs or copies, and to the many, many others who helped identify people, places, and dates. Throughout the years, many volunteers have worked with the collection, and we appreciate all that they have done. We especially thank the volunteers who worked on Mondays, week after week: Carole Cohen, Naomi Gold, Suzanne Kantziper, Matiel Leffler, and Harriet Meyerhoff.

Valerie: I would like to express my thanks and admiration to the entire Jewish community of Savannah. In the past two years, both as a newcomer to Savannah and a non-Jew, I have been happily overwhelmed by the kindness of the people here. I have consistently found people willing to patiently teach me about religious, social, and historical matters, as well as welcome me into their homes, synagogues, and organizations. Thank you for sharing your rich traditions. In addition, I would like to dedicate the work I have contributed to this book to the memory of my grandparents, Robert A. and Arlie Mae Reaves Frey. Their love for community, family, and local history drew me into archives work, for which I will always be grateful.

Kaye: It has been a pleasure working with Valerie, who has proven to be a true professional. The development of the Archives has been a very gratifying experience for me, from the original collection of materials to the creation of this book. I hope that the publication will bring a wider awareness of what the Archives has to offer.

INTRODUCTION

The Jewish community of Savannah began in July 1733, when 42 Jews landed here within five months of the colony's founding. Many of those original settlers moved on to other locations, but there are still descendants from the few who remained. As in most parts of the country, a major influx of Sephardic and German Jews occurred around the time of the Civil War. Most Eastern European Jews came at the beginning of the 20th century.

The original Jewish settlers brought with them a Torah and other religious objects, and they formed what is now known as Congregation Mickve Israel. The third oldest congregation in the United States, Mickve Israel now observes Reform Judaism. Congregation B'nai B'rith Jacob, founded in 1861, is the Orthodox synagogue. The Conservative synagogue, Congregation Agudath Achim, originated in 1903. Some smaller synagogues were formed temporarily but did not remain.

Along with the synagogues, the largest influence on the Jewish community has been the Jewish Educational Alliance, also known as the J.E.A. or the Alliance. It was founded in 1912 as a resource for the newly arrived immigrants and has also helped to unite the Jewish community.

The first Jewish families lived in what is now known as the historic district of Savannah. Gradually they moved southward. Now, while the majority still live within the city limits, many have moved into the outlying areas of the county. Once the Jews settled here, they played a major role in the economic, political, and social makeup of the city. After World War II, many of the younger people, searching for improved opportunity, moved to larger cities with the exception of those who joined family businesses. With increased prosperity in the last decade, many Jews from other parts of the country came to make their homes in Savannah, and many of the younger generation returned. Also, many older people found that the quality of life and the climate were major factors encouraging them to retire here.

Within the pages of this book are gathered images from the collection of the Savannah Jewish Archives, many of which have never been seen before by the public. The photographs depict a wide array of subjects, including both formal and informal poses. They focus primarily on the 20th century, most dating from 1920 to 1960, showing the social, political, and religious endeavors of the members of Savannah's Jewish community.

SAVANNAH JEWISH ARCHIVES

The Savannah Jewish Archives was established in 1994 as an effort to save and preserve items of historical value to the Jewish community in and around Savannah. It serves areas outside of the city and county as well, since the only other Jewish archives in the state is in Atlanta. In addition to more than 2,100 photographs, the collection consists of approximately 285 cubic feet of synagogue and organization records, oral histories, copies of the *Savannah Jewish News*, family papers, business records, and a limited number of artifacts. Congregations Mickve Israel and B'nai B'rith Jacob have both deposited much of their archival material into the archives, and gift donations have been made by Congregation Agudath Achim. At present, the bulk of the collection consists of materials from the 20th century, but some older materials are available. The outstanding Minis collection, a history of one of the first Jewish families from the 18th through the 20th centuries, is also found in the Savannah Jewish Archives. The collection is being processed by two part-time, paid staff members in addition to several regular volunteers. Access to processed materials is provided through the Georgia Historical Society's library and archives during regular library hours (Tuesday–Saturday, 10a.m. to 5p.m.). Funding is provided by Savannah Jewish Archives membership through the Savannah Jewish Federation. For information about donating materials or joining as a member, please contact the Archives.

Research for this book has been as thorough as possible. However, the Savannah Jewish Archives welcomes corrections and additional information on the people, places, businesses, organizations, and events shown. All corrections and addenda will be recorded by the Archives and be made available to researchers. For images with large numbers of people, limited page space did not always allow for complete identifications; additional information may be available for these photographs. Please contact the Savannah Jewish Archives for more information.

The Savannah Jewish Archives
501 Whitaker Street
Savannah, GA 31401
912-251-2125

One
OVERVIEW

Since Savannah is a port city, many immigrants from around the world came here and made the city their home. Some Jewish Savannahians can trace their ancestors for several generations in this city.

BYCK WEDDING, 21 NOVEMBER. The wedding of Ida Boley and David Amram Byck took place on the parlor floor of a West Jones Street home, reportedly now Mrs. Wilkes' Boarding House. From left to right are (front row, seated) Minnie (Kaufman) Byck, Lilly (Byck) Collat, Theresa "Tressie" (Sonnenberg) Byck, Levy Byck, Rachael (Amram) Byck, Jettchen (Byck) Dryfus, Eva (Cohen) Byck, and Carrie (Dann) Byck; (back row, standing) Charles Byck, Isadore Collat, Moses Byck, Ida (Boley) Byck, David Amram Byck, Moses Dryfus, Ophelia (Stern) Byck, Werner Byck, and Louis Byck.

ITZKOVITZ WEDDING, 1898. The wedding of Mollie Friedman and Charles Itzkovitz took place in Savannah.

ROSENHEIM FAMILY, 1904. Pictured are Mrs. Bert (Kayton) Rosenheim and her son, Robert Kayton. When Robert and his brothers matured, they chose their mother's maiden name. Bert Rosenheim was born in Savannah in 1874.

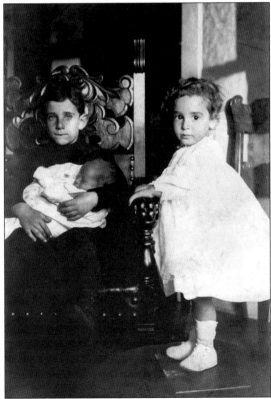

KAYTON BROTHERS, 1906. Seated in the chair is Allan Kayton, standing is Robert Kayton, and the baby is John Kayton. All three boys were born in Savannah—Allan in 1900, Robert in 1904, and John in 1906.

11

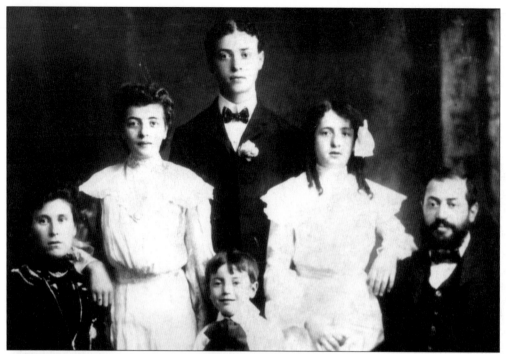

AARON LEVY FAMILY, C. 1904. The Levy family came to America shortly before this picture was taken. Pictured from left to right are (front row) Rachel (Gold) Levy, Matthew Levy, and Aaron Levy; (middle row) Sophie Levy and Ida (Levy) Barnett; (back row) Abe Levy.

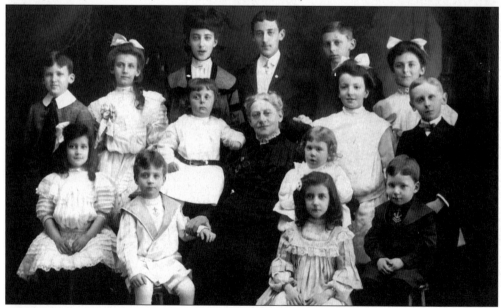

BYCK FAMILY, C. 1903. Rachael (Amram) Byck, widow of Simon "Siena" Byck, is pictured with her 14 grandchildren. Identified from eldest to youngest, they are Joseph Byck, Siena Collat, Carlyn (Byck) Heitler, Alma (Collat) Herzberg, Siena Byck, Meyer Collat, Edna (Byck) Seldner, Rhetta (Dryfus) Steinheimer, Irma (Byck) Altmayer, Mildred Byck, Charles Byck Jr., Dann Byck Sr., Edgar Collat, and David Byck Jr.

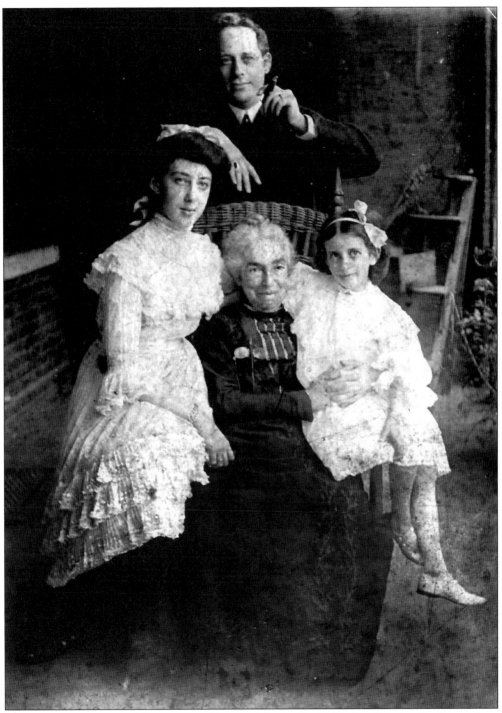

BYCK FAMILY, 1903. From left to right are (front row) Carlyn (Byck) Heitler, Grandmother Sonnenberg, and Mildred Byck; (back row) Sigmund Sonnenberg. Both girls were born in Savannah—Carlyn in 1889 and Mildred in 1896.

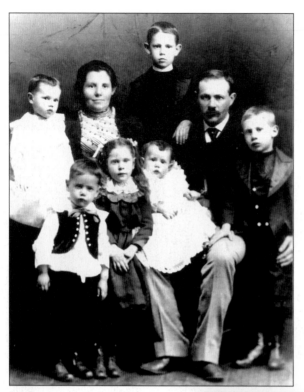

ABRAHAM BUCHSBAUM FAMILY, C. 1904. Gussie and Abraham Buchsbaum came to this country in the 1880s. Pictured from left to right are (front row) Louis Buchsbaum, Rose (Buchsbaum) Marcus, and Herbert Buchsbaum; (back row) Morris Buchsbaum, Gussie Buchsbaum, Sam Buchsbaum, Abraham Buchsbaum, and Joe Buchsbaum. Herbert was the only child in the picture born in Savannah (in September 1903). The other children were born in New York.

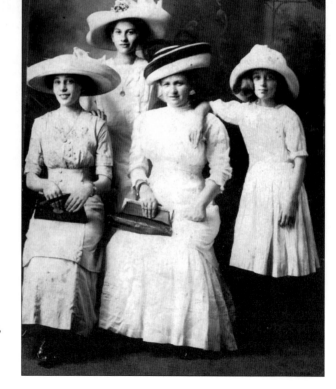

ROBINSON FAMILY AND FRIEND, C. 1910. Clara Robinson followed her husband to this country in 1903, bringing these two daughters and also two sons. The original family name was Rabinowitz. From left to right are Fannie (Cooley) Eisenberg, Fannie (Robinson) Cherkas, Clara (Mirsky) Robinson, and Pearl (Robinson) Stemer.

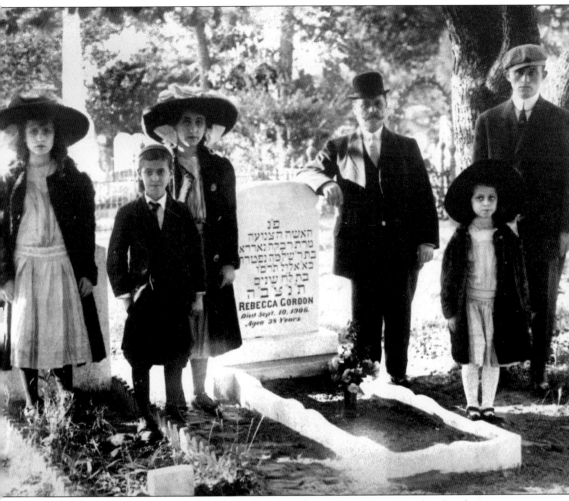

REBECCA GORDON'S UNVEILING, 1907. In the Jewish tradition, the tombstone is placed in the cemetery within the first year of the person's death. The stone is covered until the ceremony takes place, which is called the "unveiling." This stone is located in the Hebrew section of Laurel Grove Cemetery. Rebecca Gordon's children and husband, from left to right, are Belle Gordon, Max Gordon, Sarah Gordon, Herman Gordon (widower), Raye Gordon, and David Gordon.

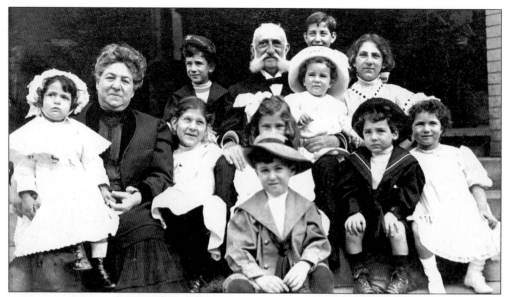

ROSENHEIM FAMILY, C. 1909. Proud grandparents Amelia and Joseph Rosenheim pose with their grandchildren. Joseph served as president of Congregation Mickve Israel from 1889 to 1918. From left to right are (front row) Richard Rich (nee Rosenheim), John Kayton (nee Rosenheim), and Ruth (Kayton) Kauffmann; (middle row) Katherine (Rosenheim) Rieser, Amelia (Sternberger) Rosenheim, Aline Rosenbaum, Tess Rosenbaum, Robert Kayton (nee Rosenheim), and Dorothy (Rosenbaum) Hammerslough; (back row) Allan Kayton (nee Rosenheim), Joseph Rosenheim, and Sydney Ross (nee Rosenbaum).

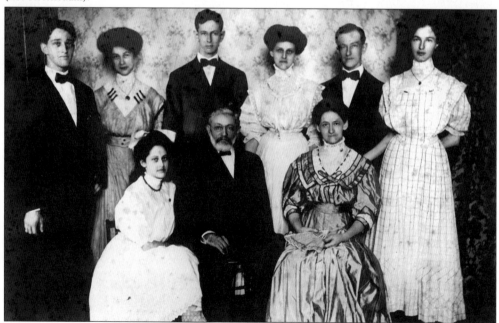

THE STERN FAMILY. From left to right are (front row) Carrie Stern, Jonathan "Jonas" Stern, and Miriam (Nussbaum) Stern; (back row) Sol Stern, Vivienne Stern, Ariel Stern, Florence Stern, Charles Stern, and Ruth Stern. Ruth was secretary of Congregation Mickve Israel for 37 years, throughout the tenures of Rabbis George Solomon, Louis Youngerman, and Solomon E. Starrels.

GRIMBALL'S POINT, C. 1910. Grimball's Point, its extensive grounds filled with huge camellia plants, was the home of Arthur Solomon Sr., who was born in Savannah in 1879. Now his granddaughter, Jan (Solomon) Friedman VandenBulck, lives there with her husband. From left to right are (first row) Sara-Henri (Solomon) Mayer, Arthur Solomon Jr., and John Kayton (nee Rosenheim); (second row) Robert Kayton (nee Rosenheim); (third row) Allan Kayton (nee Rosenheim); (fourth row) David Rosenheim, Arthur Solomon Sr., Bert (Kayton) Rosenheim, Frances (Melasky) Solomon, and an unidentified person.

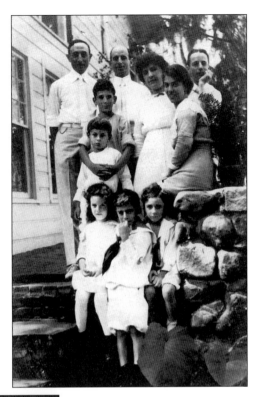

FRANK FAMILY, 1917. Carrie (Dobriner) Frank Wortsman is shown with her daughter, Juliet "Judy" (Frank) Kuhr. Juliet was born in Savannah in 1906. Carrie remarried after her first husband died.

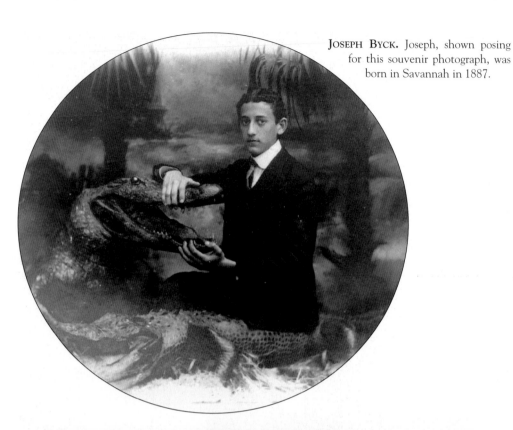

JOSEPH BYCK. Joseph, shown posing for this souvenir photograph, was born in Savannah in 1887.

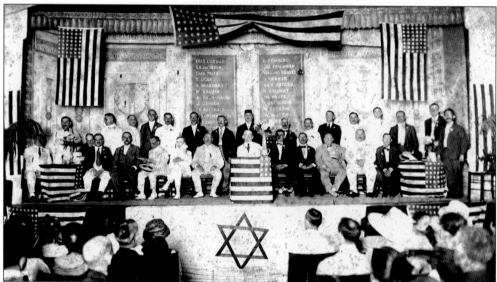

UNKNOWN GATHERING, 1920S. From left to right are (front row) an unidentified person, Edmund Abrahams, Charles Peltz, an unidentified person, Morris Bernstein, Aaron Kravitch, Samuel Blumenthal, Morris Slotin, Aaron Rauzin, Isadore "Isser" Gottlieb, Jacob Weiser, Benjamin Weitz, and Wolf Steinberg; (back row) ? Blumberg, two unidentified people, Charles Boblasky, Samuel Portman, two unidentified people, Cantor Levine, three unidentified people, Louis Weitz, three unidentified people, and Benjamin Whiteman.

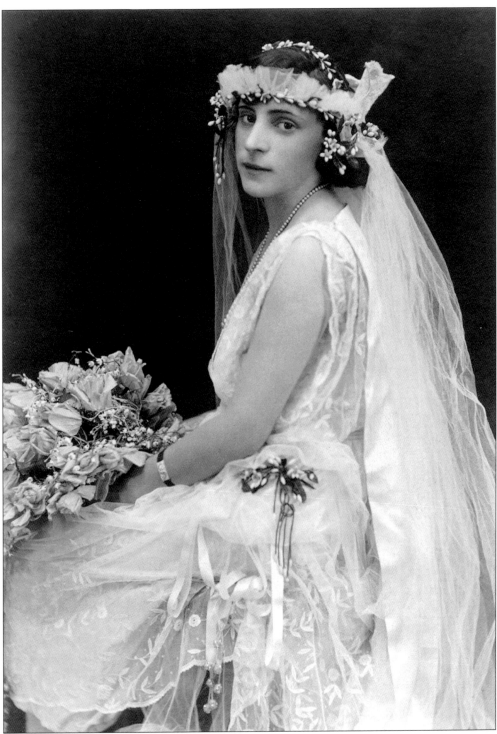

FISHER WEDDING, 1920. Rose (Brooks) Fisher Horovitz, who came to Savannah *c.* 1911, is pictured at her marriage to Morris Fisher. After Morris's death, Rose married Morris Horovitz.

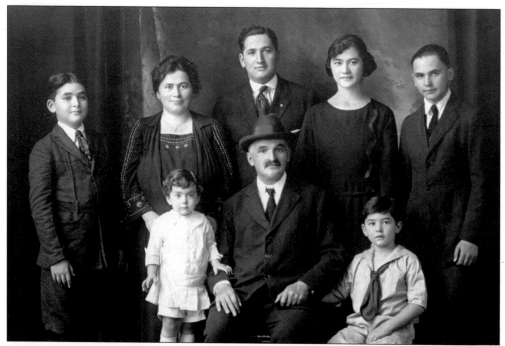

RABHAN FAMILY, 1922. Isaac and Fannie Rabhan came to Savannah in 1919. Pictured from left to right are (front row) Martin "Maier" Rabhan, Isaac Rabhan, and Archie Rabhan; (back row) Daniel Rabhan, Fannie (Ehrenfeld) Rabhan, Abe Rabhan, Sylvia (Rabhan) Rabin, and Leonard Rabhan.

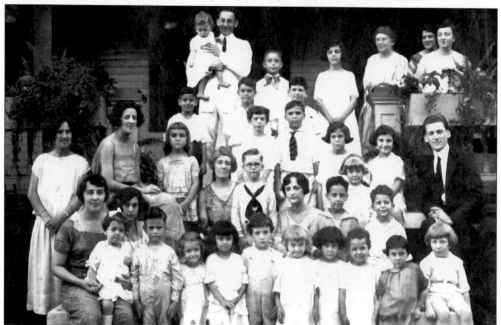

BIRTHDAY PARTY, 12 SEPTEMBER 1922. On the back of this picture is written, "Mrs. M.S. Byck's birthday party given in honor of her grandnephew Magnus S. Altmayer of Miami, Fla., who celebrated his '6th' at 21 West Park Ave. -Savannah, Ga - Sept. 21, 1922." Mrs. M.S. Byck was Theresa "Tressie" (Sonnenberg) Byck.

Two

SYNAGOGUES AND JEWISH EDUCATION

Synagogues in Savannah have always been very important to the Jewish citizens here. The three synagogues serving the area provide many activities for their members, in addition to education for both children and adults.

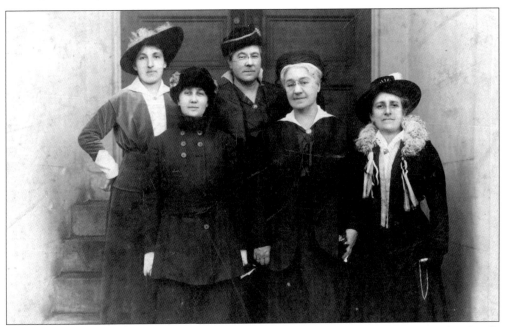

THE TEMPLE GUILD, C. 1915. The Temple Guild was the predecessor to Congregation Mickve Israel's Sisterhood. Pictured here, from left to right, are Rosie Hirsch, Julia (Fiest) Solomon, an unidentified woman, Grace Mendes, and Mrs. L. Lippman. It is not known when the Guild was established, but when it was reorganized in 1905 the officers were Mrs. I.P. Mendes (honorary president), Mrs. George Solomon (president), Mrs. L. Lippman (vice-president), and Mrs. S.B. Rosenbaum (secretary).

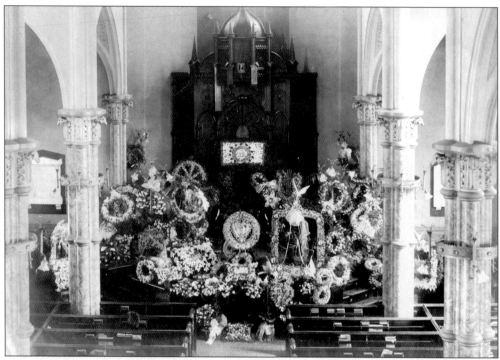

CONGREGATION MICKVE ISRAEL, 1907. The synagogue, which was built on Bull Street facing Monterey Square, was dedicated in 1878. Pictured is the interior of the Gothic building, prepared for the funeral of Herman Myers, the first Jewish mayor of Savannah.

SABBATH SCHOOL TEACHERS, 31 OCTOBER 1915. These teachers taught at Congregation B'nai B'rith Jacob. From left to right are (front row) W. Leon Friedman, Gussie Perlman, Barney Kahn, Etta (Levin) Slifkin, and Jacob Gittelsohn; (back row) Sadie Lewis, Rabbi Charles Blumenthal (superintendent), Lillian (Blumenthal) Gottlieb, Pinkus Ginsberg, and Lena (Slotin) Ehrenreich.

CONGREGATION AGUDATH ACHIM, 1941. This photograph shows the synagogue that was located on Montgomery and York streets just before the congregation's move to Drayton Street. From left to right are William Haysman, Harry Litman, Joe Kronstadt, Meyer Shensky, Jacob Lasky, Belle (Weitz) Lasky, Ida (Brown) Blumberg, Rachael (Friedman) Greenberg, Joseph Greenberg, Evelyn (Margone) Goldberg, Sylvia (Miller) Cohen, Morris Cohen, Leah (Weitzman) Chernoff, Morris Kaminsky, Esther (Rubenstein) Kaminsky, Annie (Kaminsky) Karp, Abe Karp, Samuel Tenenbaum, Bessie (Fine) Cohen, Chamke "Tante" (Kamionki) Birnbaum Tenenbaum, Louis Cohen, Nita (Cohen) Kramer Beasley, Bertha (Rubenstein) Ward, Frank Ward, Eunice (Reznick) Steinberg, Wolf Steinberg, Nathan Marcus, two unidentified people, Rebecca (Onskinsky) Galin, Jack Galin, and Clara (Kronstadt) Galin.

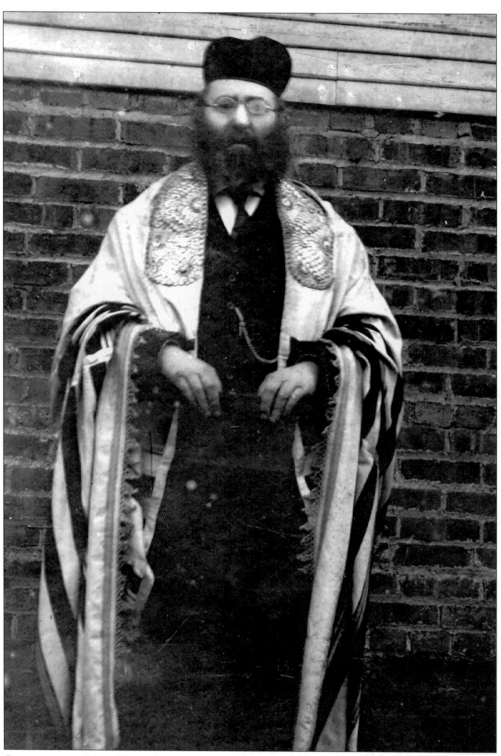

CONGREGATION B'NAI B'RITH JACOB. Cantor Avram David Hurwitz served Congregation B'nai B'rith Jacob from 1910 to 1916.

HERMAN MYERS. Herman Myers was the first Jewish mayor of Savannah, serving from 1895 to 1897, and again from 1899 until his death in 1907.

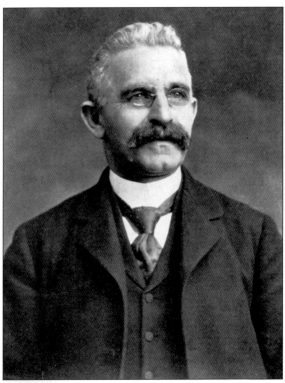

RABBI GEORGE SOLOMON, C. 1939. Rabbi George Solomon served Congregation Mickve Israel from 1903 to 1945. He was married to Julia Fiest. From 1926 to 1945 the Solomons owned and operated a Jewish camp. Camp Osceola was located on Lake Osceola near Hendersonville, North Carolina.

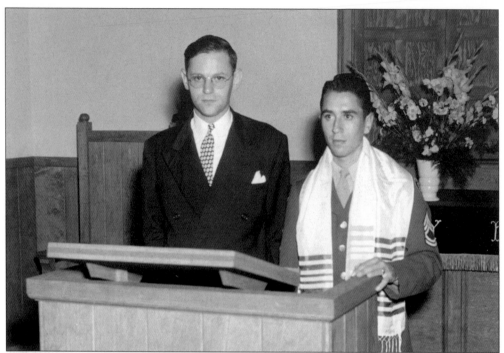

CONGREGATION MICKVE ISRAEL, 1940S. From left to right are Rabbi Louis Youngerman and S/Sgt. Robert Blumstein, cantor. Rabbi Youngerman served Congregation Mickve Israel from 1944 to 1948.

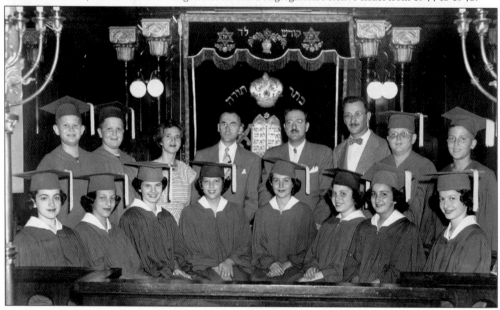

SUNDAY SCHOOL AND HEBREW SCHOOL GRADUATION, 1949. Congregation B'nai B'rith Jacob operated this school, which taught the Hebrew language and Jewish traditions. Pictured from left to right are (front row) Beatrice Sklansky, Sandra (Safer) Weiss, Jane (Ginsberg) Morse Berger Rosenblum, Betty (Weiss) Lasky, Sally (Rotkow) Levine Sanders, Janet (Silverman) Reed, Sonia (Robbins) Greenfield, and Suzanne (Ginsberg) Kantziper; (back row) Murray Itzkovitz, Anchel Samuels, Frieda Rosenberg, Samuel Rosenberg, Rabbi A.I. Rosenberg, Bernard Jacobson, Melvin "Mesch" Hirsch, and Bernard Hirsch.

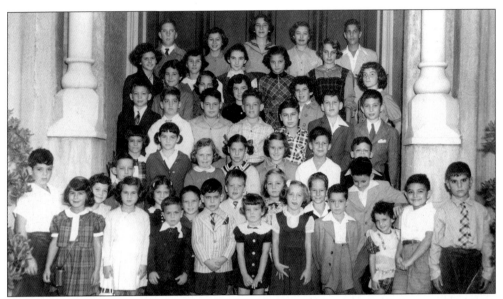

MICKVE ISRAEL SUNDAY SCHOOL, 1950–1951. This picture was taken in front of the synagogue, facing Monterey Square, on Bull Street between Gordon and Wayne Streets.

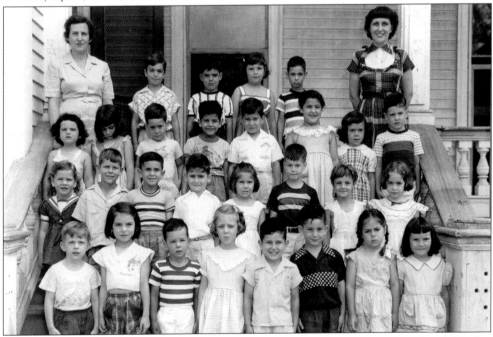

BUREAU OF JEWISH EDUCATION PRE-SCHOOL, C. 1950. From left to right are (first row) Jack Herckis, Berta (Golcman) Friedman Adams, Stephen Richman, Simone (Broome) Wilker, Alan Tanenbaum, Jerry Shensky, Sherry (Kantsiper) Gold, and Barbara Diamond; (second row) Lynne Bernstein, Howard Ginsberg, Robert Segall, Moses Robbins, Irene (Cohen) Michaels, Edward Wexler, Iris (Diemar) Ginsberg, and Frances Garfunkel; (third row) Judy Slotin, Lynn (Rabhan) Owens, Harvey Sussman, Jerry Portman, Melvin Haysman, Renee (Wagner) Shoob, Brenda (Elman) Salter, and Arthur Geffen (fourth row) Sauchie (Kaplan) Blumenthal, Harold Heyman, Daniel Kramer, Barbara (Jacobson) Meddin, Alan Serotta, and Eunice (Odrezin) Finn.

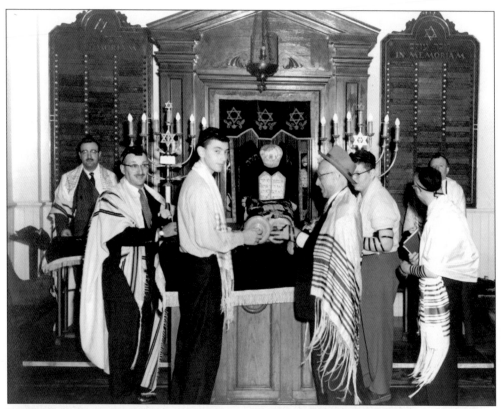

B'NAI B'RITH JACOB JUNIOR CONGREGATION, 6 DECEMBER 1953. Pictured at a Chanukah party, from left to right, are Rabbi A.I. Rosenberg, Bernard Jacobson, Nathan Rabhan, Benjamin Karpf, Melvin "Mesch" Hirsch, and Samuel Rosenberg.

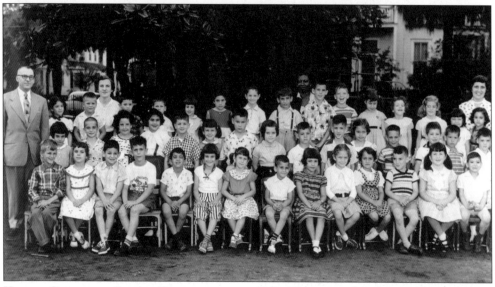

HEBREW COMMUNITY SCHOOL KINDERGARTEN, C. 1955. This group of students and teachers posed outside the new J.E.A. building on Abercorn Street. Pictured are principal Samuel Rosenberg and teachers Sauchie (Kaplan) Blumenthal and Eunice (Odrezin) Finn.

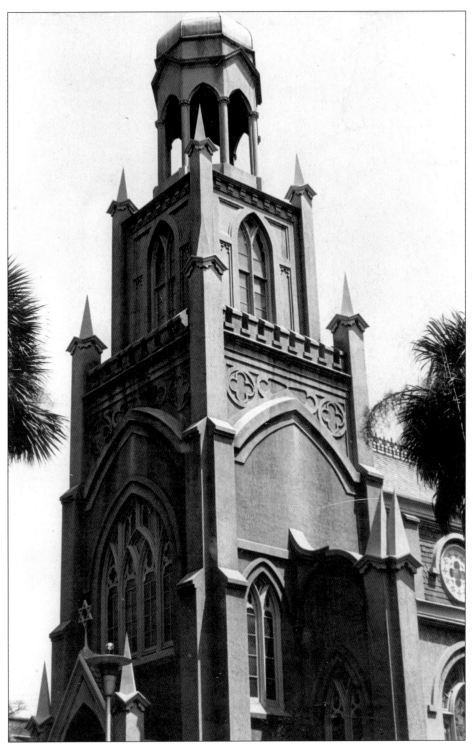

MICKVE ISRAEL. Pictured is the exterior of the only Gothic synagogue in this country. Dedicated 11 April 1878, it was built on Bull between Gordon and Wayne Streets, facing Monterey Square.

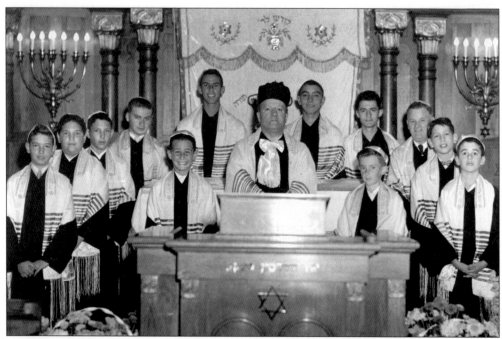

B'NAI B'RITH CHOIR, 1954. From left to right are (front row) Jay Rabhan, Cantor Albert Singer, and Gary Weil; (back row) Irwin Safer, Elliott "Brody" Palefsky, Jack Levy, Solomon Epstein, Walter Rabhan, Nathan Rabhan, Jules Rosenberg, Israel Safer, Louis "Wolf" Sutker, and Irvin Asher.

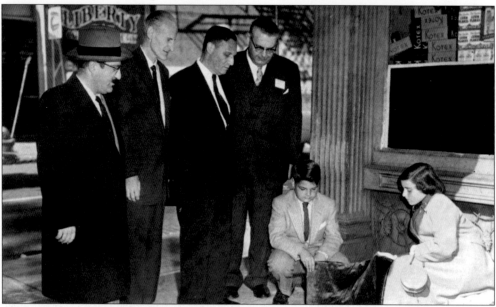

UNVEILING MARKER, 17 JANUARY 1954. This marker, designating the original site of Mickve Israel, the first synagogue in Georgia, was unveiled at the northeast corner of Liberty and Whitaker Streets. From left to right are Rabbi A.I. Rosenberg (B'nai B'rith Jacob Synagogue), Meyer Kronenberg (retiring president of the Southeast Council of the U.A.H.C.), Rabbi Solomon E. Starrels (Mickve Israel Synagogue), Raymond "Bus" Kuhr (master of ceremonies), Robert P. Minis (descendant of Abraham Minis), and Joan (Levy) Levy (descendant of Benjamin Sheftall). Minis and Sheftall were two of the original settlers.

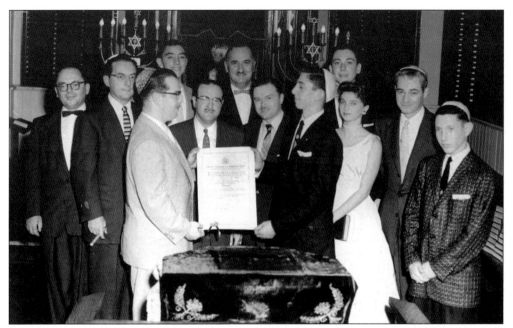

FOUNDING OF THE YOUTH ORTHODOX UNION, 1955. The Youth Orthodox Union was later named the National Council of Synagogue Youth. From left to right are (front row) Rabbi Harold Cohen, Rabbi A.I. Rosenberg, Cantor Gerwitz, Harold Solomon, and Miriam Jacobson; (back row) Philip Veit, Benjamin Kantsiper, Nathan Rabhan, Abe Rabhan, Albert Rabin, Joseph Goldberg, and Jack Levy.

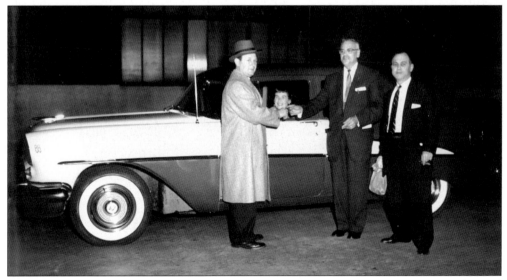

B'NAI B'RITH JACOB ANNUAL BROTHERHOOD DINNER, 13 FEBRUARY 1955. Irving "Nat" Nathan and his wife, Betty (Adler) Nathan, pictured on the left, were the winners of a car in the annual fund-raiser. Louis Black (chairman) and David Weiner (co-chairman) are on the right.

B'NAI B'RITH JACOB CONFIRMATION, 1959. From left to right are Mitzi (Kantziper) Faurest, Donna Minkovitz, Sara (Cantor) Wheeler, Rabbi A.I. Rosenberg, Faye Kirschner, Sandra (Kantsiper) Goodman, and Sydney (Solomon) Ratner.

HEBREW COMMUNITY SCHOOL, 28 MAY 1957. This school graduation took place at the J.E.A. The students, from left to right, are (front row) Irene Huth, Judy (Plotkin) Altman, Mickey (Ginsberg) Katz, Judy (Rosenberg) Becker, and Sally (Karpf) Krissman; (back row) Louis Weinstein, Irvin Asher, Harvey Rubin, Samuel "Butch" Tenenbaum, Lloyd "Skippy" Goodman, Joel Rotkow, and Stuart Rudikoff.

Three

JEWISH EDUCATIONAL ALLIANCE

Not only does the Jewish Educational Alliance provide its own extensive programming, but many local branches of national or international organizations meet there regularly. It is also open to the general community.

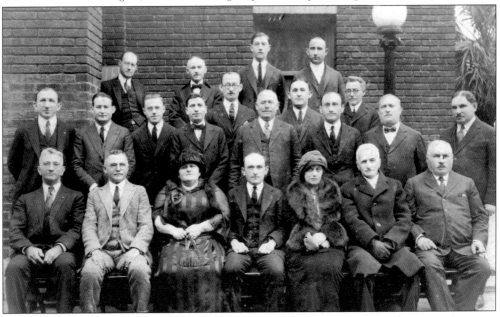

BOARD OF DIRECTORS, 1922. Board members, from left to right, are (first row) Jacob Gazan, Max Blumenthal, Frances Kandel, Morris Slotin, Eugenie (Hecht) Garfunkel, an unidentified member, and Benjamin Weitz; (second row) Isaac Blumberg, Alex Volpin, Louis Silverman, Hyman Horovitz, Samuel Blumenthal, Harry Ehrenreich, William Weiser, and Louis Weitz; (third row) Meyer Cherkas, Samuel Hornstein, and Morton Levy; (fourth row) Jacob Weiser, Jacob Bernstein, William Pinsker, and Charles Boblasky.

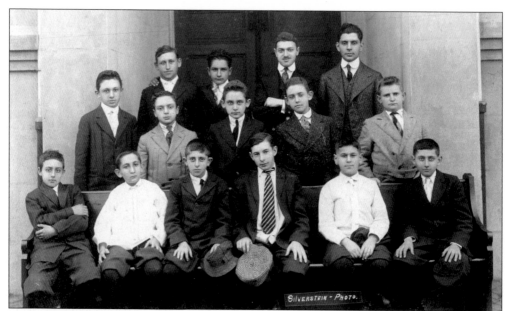

YOUNG MEN'S HEBREW ASSOCIATION JUNIORS, C. 1916. The Y.M.H.A. drew up a constitution and by-laws in 1889. From left to right are (front row) Samuel Goodman, Joseph Center, ? Morris, Leon "Lukie" Tenner, Asa Meddin, and Robert Kaminsky; (middle row) Fred Rotkow, Joseph Greenberg, Jacob Stone, Alex Mazo, and Leon Gottlieb; (back row) Louis "Bum" Lasky, Benjamin Chernoff, Isidor Kadis, and an unidentified member.

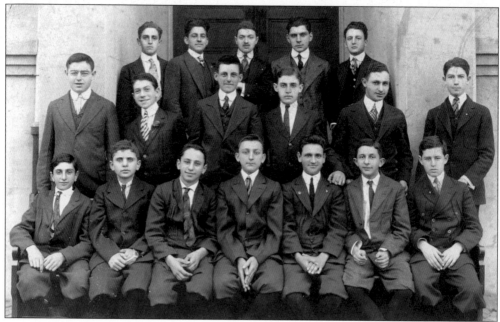

YOUNG MEN'S HEBREW ASSOCIATION SENIORS, 1915. From left to right are (front row) Samuel Rotkow, Mike Kronstadt, Louis "Bum" Lasky, Abraham "Chief" Harris (nee Horovitz), Mortimer "Bud" Fischer, Selig Richman, and Joseph Schmalheiser; (middle row) Isadore or Joseph Apolinski, Herbert Levington, Morris Rubin, Jacob Stone, Frank Lasky, and Abram Levington; (back row) Elry Stone, Morris Horovitz, Isidor Kadis (superintendent), an unidentified member, and Jacob Gittelsohn.

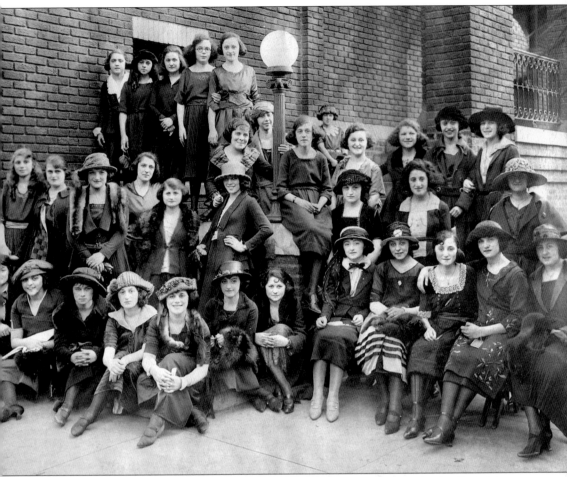

GLEE CLUB, C. 1921. From left to right are (first row) Marcella (Isaacs) Schein, Bertha (Bradley) Cohen, Etta (Mirsky) Feidelson, ? Levin, Rosalie Itzkovitz, Eva (Alpert) Morton, Celia Markowitz, Minnie (Richman) Kantsiper, Ann (Cranman) Pollack, Jennie Lesser, Hannah Nash (nee Nochomovsky), and Lena (Cranman) Weitz; (second row) Fannie Levine, Ruth (Weiser) Silverman, Ida (Chernoff) Schreiver, an unidentified club member, Rita (Isaacs) Rotkow, Selina (Friedman) Froelich, ? Lipsitz, Lilly (Feinberg) Gerber, and Sophie (Sutker) Guyes; (third row) Clara (Kronstadt) Galin, Goldie (Davis) Schmalheiser, Henrietta Blumenthal, Mina (Mazo) Levington, Esther (Richman) Greenfield, Bertha Foster, and two unidentified members; (back row) Ida Pinzer, Bea (Rabhan) Chaskin, ? Mirsky or Rose Levin, an unidentified member, and Yetta (Pollock) Siegel.

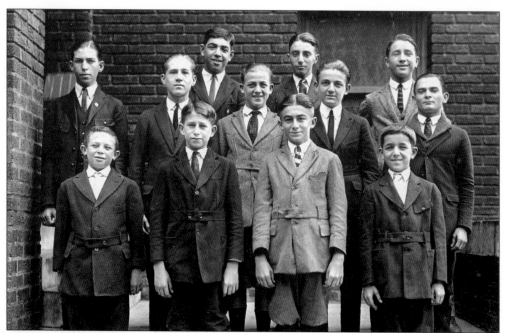

HONOR BOYS, FIRST EFFICIENCY CONTEST, 1922. From left to right are (front row) Morris Homansky, Solomon "Sockie" Perlman, H. Sol Clark (winner), and Morris "Pony" Wagman; (middle row) Benjamin Sheftall, Samuel Rassin, Samuel Goodman, Joseph "Pete" Danish, and Harry Kolman; (back row) Abram "Sleepy" Wagman, Maxwell "Mike" Brooks, and Joseph Mirsky (second place).

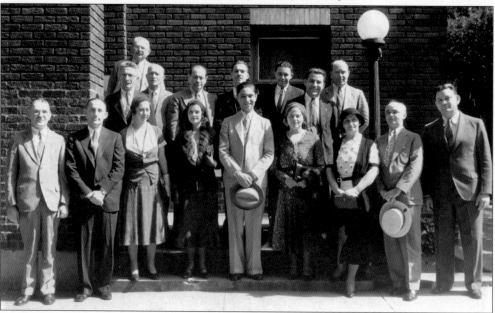

FUND DRIVE, MAJORS AND CAPTAINS, 1931. From left to right are (front row) Louis Sutker, Samuel Hornstein, Goldie (Davis) Schmalheiser, Matilda (Kaplan) Meddin, Rabbi Nathan Rosen (B'nai B'rith Jacob), Anna Lou Friedman, Ida (Wilensky) Fine, Morris Bernstein (director of drive), and Max Hornstein; (middle row) Max Richman, Jacob Weiser, Isaac Meddin, David Weiner, Anchel "Unchie" Friedman, Morris Horovitz, and Nathan Greenberg; (back row) Fred Rosen.

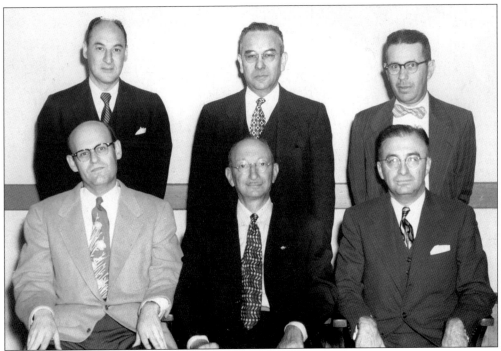

PAST PRESIDENTS, OCTOBER 1952. From left to right are (front row) William Wexler, Morton Levy, and H. Sol Clark; (back row) Bernard Eichholz, Emanuel Lewis, and Harry Friedman.

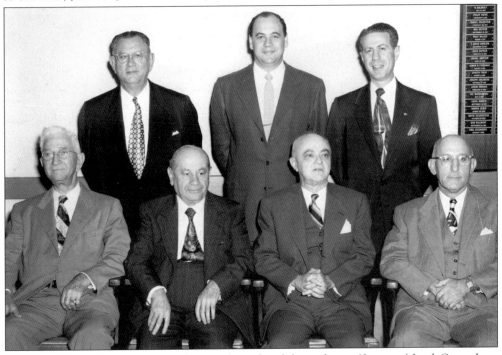

PAST PRESIDENTS, OCTOBER 1952. The men above, from left to right, are (front row) Jacob Gazan, Isaac Meddin, Morris Bernstein, and Samuel Hornstein; (back row) Max Hornstein, David Rosenzweig, and Benjamin Silverman.

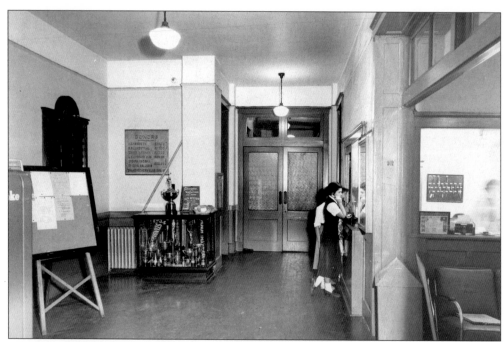

BUILDING FUND CAMPAIGN, NOVEMBER 1952. Pictured is the main entrance of the building on Barnard Street. Preparations were being made to move from the building on Barnard Street facing Pulaski Square to Abercorn Street near DeRenne Avenue. (The people in the photograph have not been identified.)

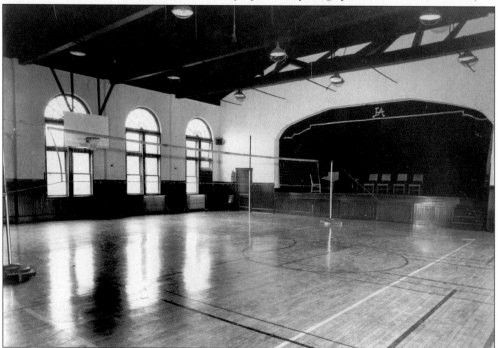

BUILDING FUND CAMPAIGN, NOVEMBER 1952. This photograph of the auditorium/gymnasium on Barnard Street will be familiar to many who spent hours participating in sports and other forms of entertainment in the building.

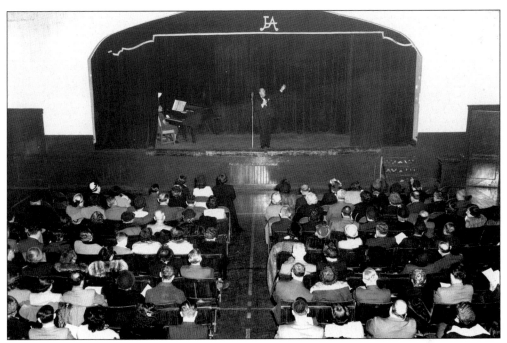

J.E.A. AUDITORIUM. The auditorium was used for many events such as this stage production.

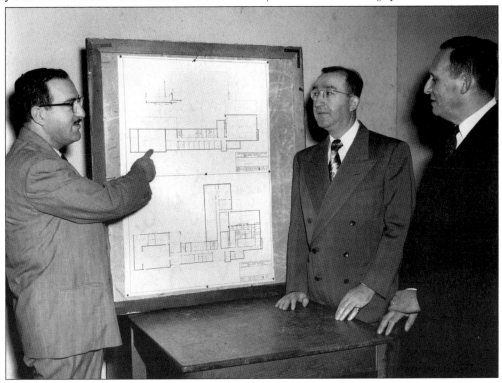

BUILDING FUND CAMPAIGN, NOVEMBER 1952. These three rabbis helped plan for the future building. From left to right are Rabbi A.I. Rosenberg (B'nai B'rith Jacob Synagogue), Rabbi Isidore Barnett (Agudath Achim Synagogue), and Rabbi Solomon E. Starrrels (Mickve Israel Synagogue).

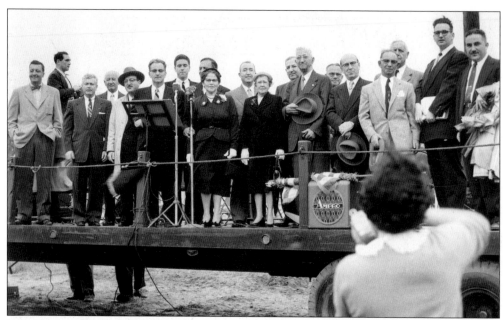

GROUNDBREAKING FOR NEW BUILDING ON ABERCORN STREET, 28 FEBRUARY 1954. The day finally arrived when something concrete could be seen. From left to right are Jack Cay, Benjamin Portman, Raymond Rosen, Samuel Robinson, Rabbi A.I. Rosenberg (B'nai B'rith Jacob Synagogue), Albert Tenenbaum, Arnold Tenenbaum, Rabbi Solomon E. Starrels (Mickve Israel Synagogue), Anna Lou Friedman, Rabbi Isidore Barnett (Agudath Achim Synagogue), Julia (Fiest) Solomon, Larry Karp, Jacob Gazan, Henry Levington, Cantor Josef Salzman (Agudath Achim Synagogue), Philip Bodziner, R.H. Mayer (county commissioner), Irwin Giffen, and Paul Kulick.

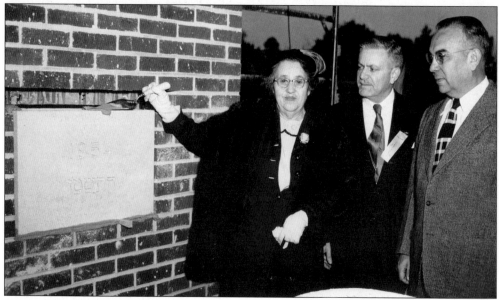

CORNERSTONE CEREMONY, 31 OCTOBER 1954. Mrs. Morris Slotin was chosen to lay the cornerstone because her husband had been instrumental in reopening the building on Barnard Street after World War I. Pictured from left to right are Elizabeth "Lizzie" (Schneider) Slotin, Raymond Rosen, and Emanuel Lewis.

COMPLETED NEW BUILDING. The new building on Abercorn Street was occupied 1 June 1955, with a formal dedication 12 October 1955. Major renovations took place in the 1990s.

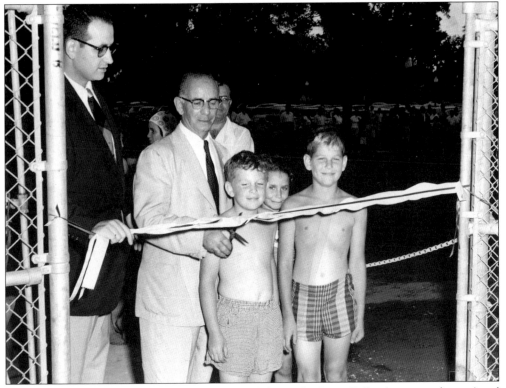

POOL DEDICATION, 19 JUNE 1955. Pictured from left to right, Irwin Giffen (executive director) and Philip Bodziner cut the ribbon to allow eager youngsters, Jack Herckis, Barbara (Seeman) Gottlieb, and Howard Ginsberg take the first dip in the pool.

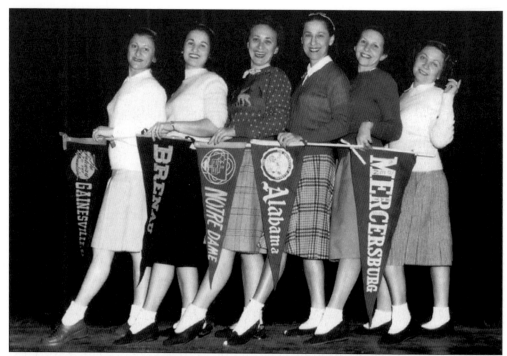

WOMEN'S CLUB, 25 MARCH 1947. These women presented a specialty act as part of the variety show commemorating the silver anniversary of the Women's Club. They are, from left to right, Dorothy (Raskin) Rosenthal, Rachel (Chernoff) Javetz, Evelyn (Ward) Karsman, Helene (Karsman) Movsovitz, Dora Portman, and Molly (Segall) Wexler.

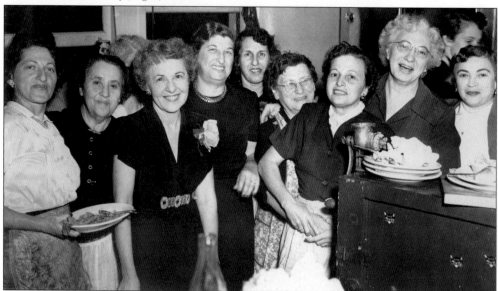

EPPES ESSEN, LATE 1940S. Translated from Yiddish, "eppes essen" means "something to eat." The meal of traditional Jewish foods that preceded the J.E.A. annual meeting was referred to as an "eppes essen." The cooks are, from left to right, Hilda (Perlman) Weiner, Elizabeth "Lizzie" (Schneider) Slotin, Mina (Mazo) Levington, Fannie (Estroff) Mirsky, Sadye (Steinberg) Rabhan, Bessie (Dolgoff) Kaplan, Mildred (Goodman) Rosen, Rebecca (Rosenthal) Bergrin, and Anna (Alstock) Samuels.

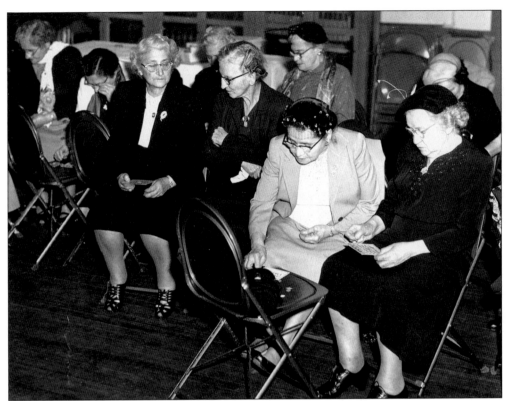

GOLDEN-AGERS SOCIAL HOUR, C. 1954. Bingo has always been a popular pastime for the senior citizens. Pictured on the front row, from left to right are Fannie Wexler, Ann Bernstein, Bessie Kolman, and an unidentified woman.

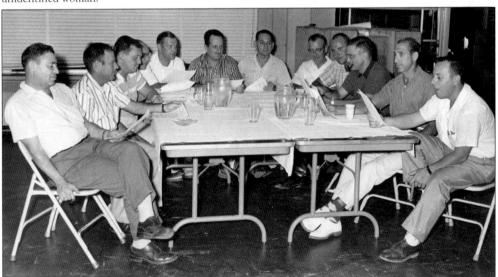

MEN'S CLUB EXECUTIVE COMMITTEE, 4 SEPTEMBER 1957. From left to right are Bernie Lennox, Harry Kaplan, Lawrence Elman, Harry Richman, Melvin Arnstein, Julius Rudikoff, Herman Barnett, Max Brueck, Malcolm Cook (physical education director), Sanford Wexler, Harry Eichholz, and Earnest Siegel (program director).

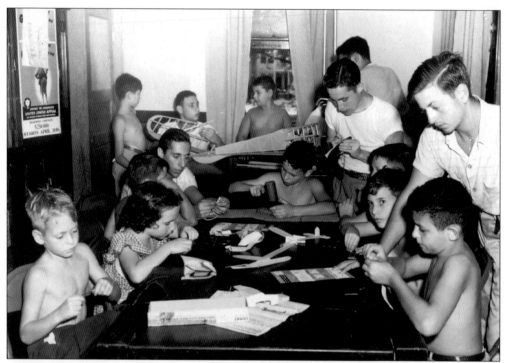

SUMMER CAMP CRAFTS, 8 JULY 1946. Pictured, among others, are Robert Hirsch, Doris "Dottie" (Eisenberg) Lynch, William Lasky, Harold Javetz, Gerald Greenfield, Jack Berliner, Arnold Cohen, and Jules Homans.

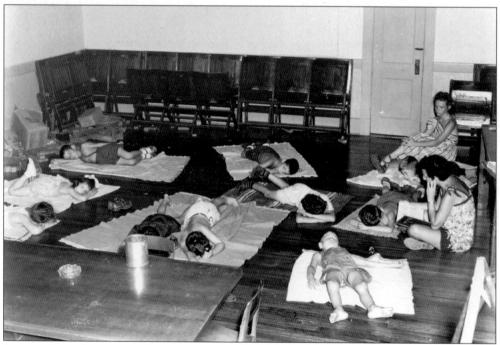

SUMMER CAMP NAP TIME, 8 JULY 1946. The many activities of camp made nap time necessary for the younger campers.

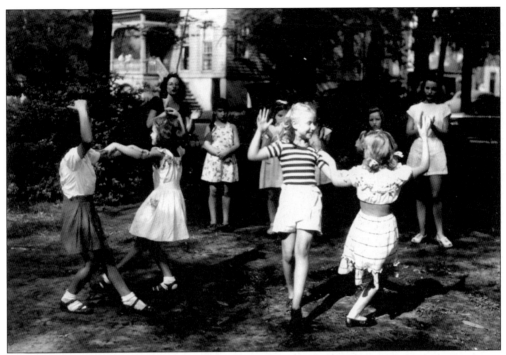

SUMMER CAMP ACTIVITIES, AUGUST 1947. Shown here are unidentified campers learning a dance. Other activities included swimming, arts and crafts, sports, and other typical camp pastimes.

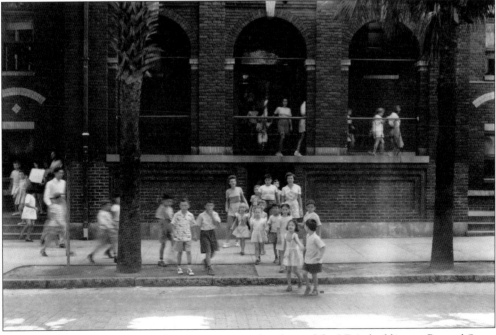

SUMMER CAMP, AUGUST 1947. Campers are pictured in front of the J.E.A. building on Barnard Street facing Pulaski Square. Pictured among others are Barbara (Mirsky) Seligman, Murray Freedman, Isser Gottlieb, Lillian (Heyman) Lowe, Arnold Tillinger, Brenda (Hirsch) Schimmel, Gilbert Kulick, Lynn (Schlosser) Levin, Beth (Odess) Fagin Childress, Sammy Feinberg, and Frances (Solomon) Gretenstein.

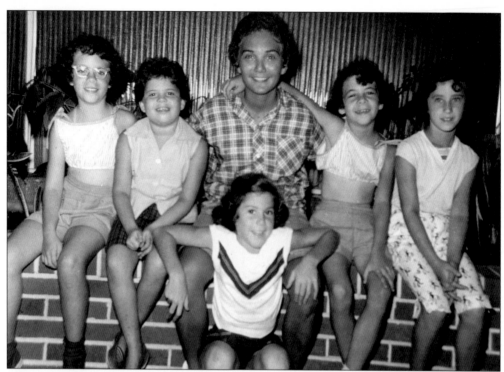

SUMMER CAMPERS, 1957. From left to right are (front row) Susan (Wagger) Karpf; (back row) Sonia Henkle, Rosalind Weiner, Elpie Paris, Andrea Henkle, and Marcia ?.

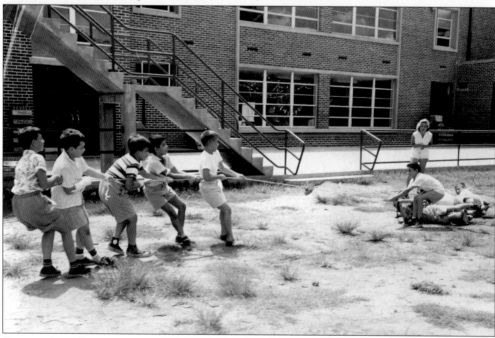

SUMMER CAMP GAMES, 1955. Campers are shown playing tug-of-war behind the new J.E.A. building on Abercorn Street. From left to right are Joel Rotkow, Harvey Sussman, Melvin Haysman, Jerry Portman, Gary Levinson, Harriet Rosen, Mark Schneider, and Howard Ginsberg.

Four

RECREATION AND SPORTS

Although many Jewish residents have had to work hard to make ends meet, they have also taken time to enjoy themselves, whether in the city or at the nearby beach. All types of sports have played a prominent part in the Jewish community; teams and individuals have competed against others both within and outside of the city and state.

YOUNG PEOPLE'S RECREATION CLUB, C. 1915. From left to right are (front row) an unidentified club member, Lily (Maril) Jacobs, Edith (Lipsitz) Sader, Fannie (Cooley) Eisenberg, an unidentified member, Lil (Schmalheiser) Sutker, ? Levine, Lena (Slotin) Ehrenreich, Mina (Mazo) Levington, Sara (Levy) Kaplan, Flo (Slifkin) Gordon, and Etta (Levin) Slifkin; (back row) an unidentified member, Joseph Schmalheiser, three unidentified members, Rabbi Charles Blumenthal, Isaac Levington, Victor Sutker, an unidentified member, Fred Ehrenreich, and Barney Slifkin.

TYBEE ISLAND. Herbert Kayton (shown on the far left) shared a game of football on the beach with some unidentified friends.

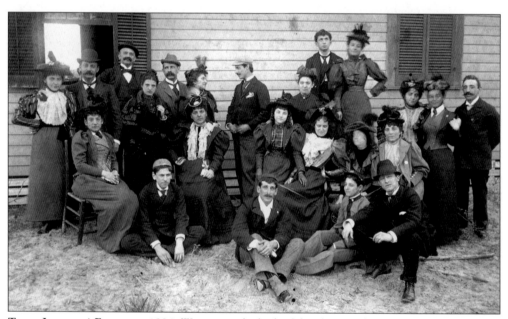

TYBEE ISLAND, 4 FEBRUARY 1894. Written on the back of the photograph is, "Compliments of David J. Rosenheim," but no one is identified. Times have certainly changed since beach-goers dressed in this fashion.

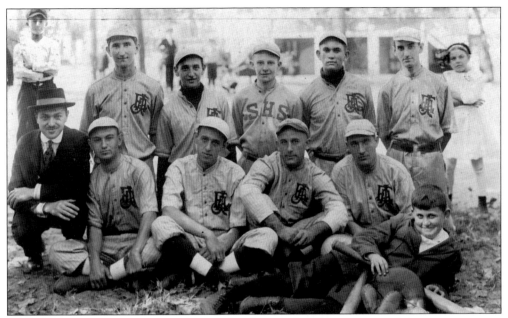

J.E.A. BASEBALL TEAM, 1915. The Jewish Educational Alliance sponsored many sports teams throughout the years. From left to right are (front row) Isidor Kadis, Fred Ehrenreich, Emanuel Kandel, Samuel Hornstein, Sam Abrams, and Charles Hornstein (batboy); (back row) Joseph Gottlieb, Perry Singer, Louis Buchsbaum, Max Hornstein, and Meyer "Mike" Goldberg. In background are Abraham "Chief" Harris (nee Horovitz) and ? Danish.

BASEBALL, WORLD WAR I. When this photograph was reproduced in the *Savannah Evening Press* on 11 September 1971, the caption stated, "World War I was in its early months when these eager football players gathered for a photograph at the 'South Atlantic League Baseball Park', located at Ash Street where the old Thunderbolt streetcar crossed on its way to the resort and fishing community on the Wilmington River. They were members of the Forsyth Park Playground team, and are identified by John J. Fogarty, who owns the picture"

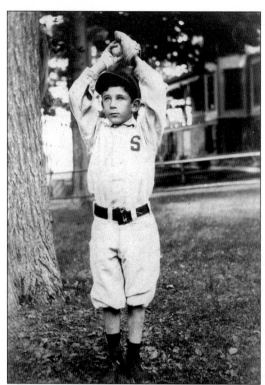

BASEBALL, AUGUST 1909. This little slugger is Allan Kayton (nee Rosenheim). Allan and his brothers adopted their mother's maiden name.

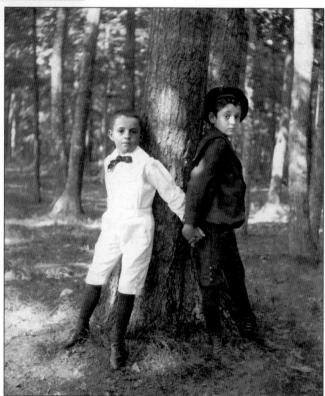

OUTDOOR RECREATION, C. 1909. Robert Kayton (left) is pictured here with his brother, Allan Kayton.

50

GOLF, C. 1920. Golfer Allan Kayton takes a swing at the ball.

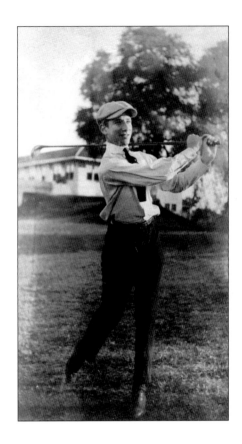

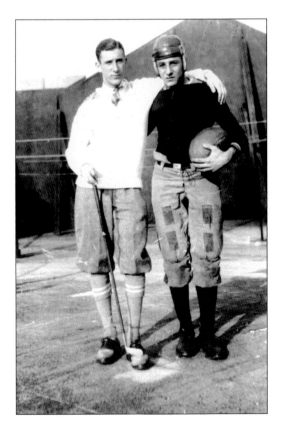

GOLF AND FOOTBALL, C. 1923. Both Kayton brothers enjoyed sports but not the same one. Allan Kayton is pictured on the left and Robert Kayton is on the right.

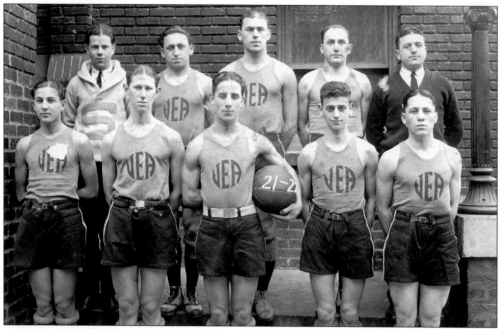

J.E.A. BASKETBALL, 1921–1922. Basketball was probably the most popular sport sponsored by the J.E.A. From left to right are (front row) Louis "Libe" Gittelsohn, Isadore "Izzy" Izkovitz, Fred Rosolio (captain), Mortimer "Bud" Fischer, and Harry Marcus (also known as Dick Leonard); (back row) Frank Buchsbaum (cheerleader), Louis "Bum" Lasky, Emanuel Kandel, Jacob "Jack" Sauls (nee Savilowsky), and Jerome Eisenberg (physical education director).

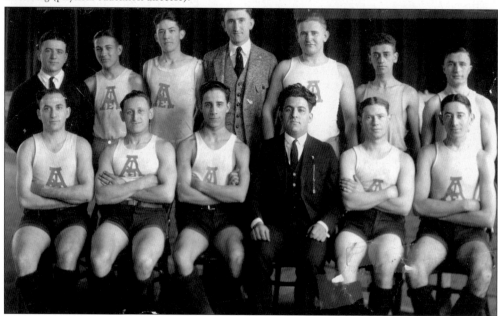

J.E.A. SOFTBALL TEAM, 1921. From left to right are (front row) Jacob "Jack" Sauls (nee Savilowsky), Louis "Bum" Lasky, Fred Rosolio, Morris Horovitz, Morris Buchsbaum, and Meyer "Slim" Blumberg; (back row) Jerome Eisenberg, Louis "Libe" Gittelsohn, Julian Foss, Joseph Gottlieb, Leon Gottlieb, Mortimer "Bud" Fischer, and Louis Pinzer.

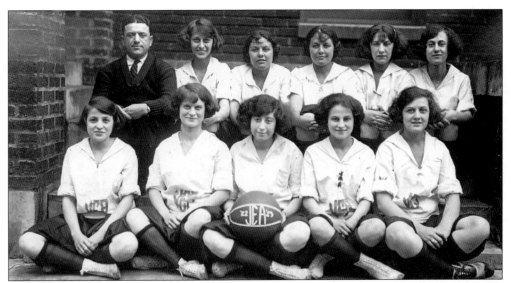

J.E.A. WOMEN'S BASKETBALL, 1923. From left to right are (front row) Mildred (Goodman) Rosen, Belle (Weitz) Lasky, Rosaline (Levy) Tenenbaum, Ellie Friedman, and Hilda (Lind) Schick; (back row) Jerome Eisenberg, Matilda "Mat" (Shapiro) Clark, Rose Danish, Mary Danish, Gussie (Nathan) Diener, and Judith Blumenthal.

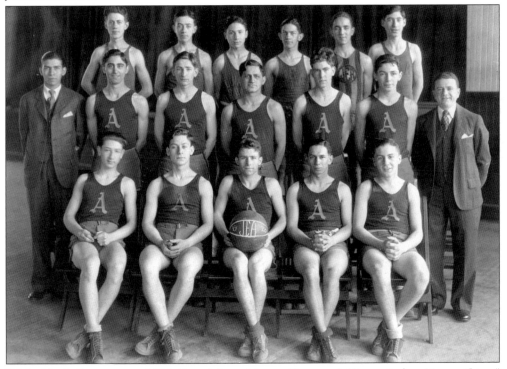

J.E.A. MEN'S BASKETBALL, 1928. From left to right are (front row) Hyman Sutker, Lipman "Lippy" Wise, Bernie Slotin, Jerome Lewis, and Isadore "Musky" Movsovitz; (middle row) Benjamin Sheftall, Louis Wexler, Milton "Buster" Gottlieb, Louis Perlman, Samuel Sutker, Joseph "Brother" Wilensky, and Jerome Eisenberg; (back row) Benjamin Silverman, Leon Kraft, an unidentified player, Hymie Longwater, Morris "Pony" Wagman, and an unidentified player.

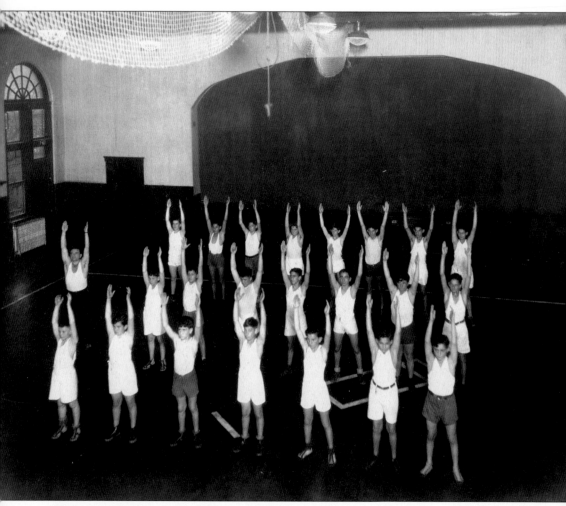

J.E.A. CALISTHENICS CLASS, 1930. Fitness classes have been around longer than we may have realized. This class took place in the J.E.A. gym on Barnard Street.

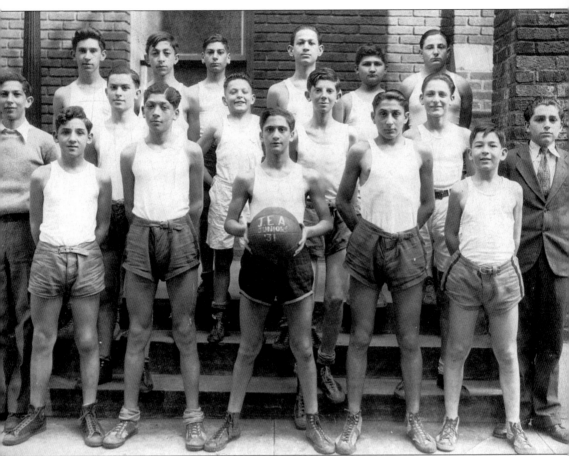

J.E.A. BASKETBALL, 1931. From left to right are (front row) Milton Mazo, William Cohen, Sanford Wexler, Bernard "Bunny" Fink, and Irvin Center; (middle row) William "Muttsy" Longwater, Mickey Deich, Leo Center, Melvin Blair, Milton Fink, and Milton Lipsitz; (back row) Seymour Kandel, Beryl Morris, Gerald Meddin, Gilbert Kanter, Irving "Rollie" Kaminsky, and Jack Bryan.

TYBEE ISLAND PAVILION, C. 1933. Pictured is Aaron Buchsbaum, who now makes his permanent home at Tybee Island. The pavilion shown in the photograph, erected by the Central of Georgia Railway in the early 1900s, was named the Tybrisa. It burned down in 1967 and was finally replaced by a new pavilion and pier in 1996.

TYBEE ISLAND, 1939. Miriam (Schmalheiser) Nathan is shown enjoying a spring day at the beach.

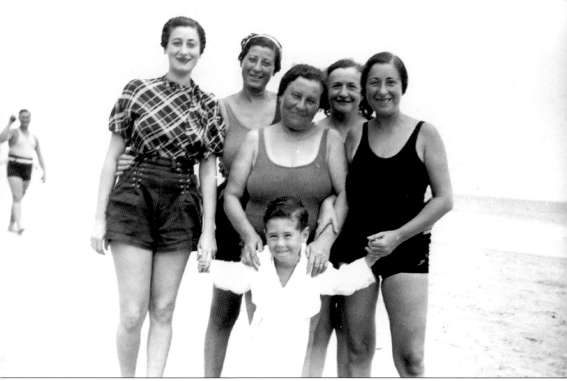

TYBEE ISLAND, AUGUST 1934. Aaron Buchsbaum, in front, enjoys the company of his proud mother, grandmother, and aunts. From left to right, in the back row, are Dorothy (Levy) Wexler, Rosaline (Levy) Tenenbaum, Rachel (Gold) Levy, Ida (Levy) Barnett, and Sarah (Levy) Buchsbaum.

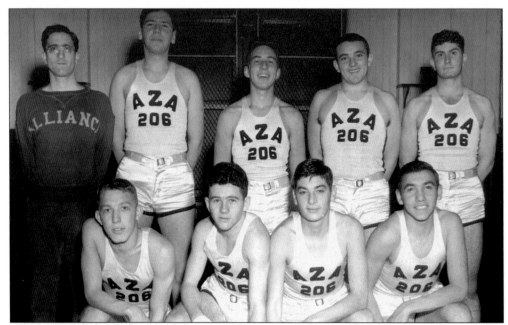

A.Z.A. BASKETBALL, 1946. Some sports teams were sponsored by organizations, such as this B'nai B'rith youth club. From left to right are (front row) Philip Hoffman, Bernard "Buddy" Portman, Roger "Roddy" Meddin, and Ramon Udinsky; (back row) Sanford Wexler (coach), Murray Arkin, Irvin Konter, Harris Slotin, and Alan Gottlieb.

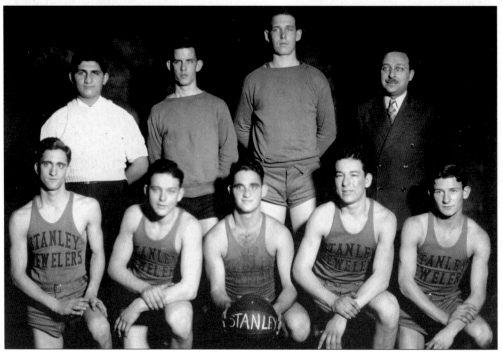

STANLEY JEWELERS' BASKETBALL TEAM, C. 1940. Some local businesses sponsored sports teams. From left to right are (front row) Sanford Wexler, Leo Center, Maurice Alpert, Irvin Center, and Irving "Nat" Nathan; (back row) Irving "Rollie" Kaminsky, two unidentified men, and Jack Perlstein.

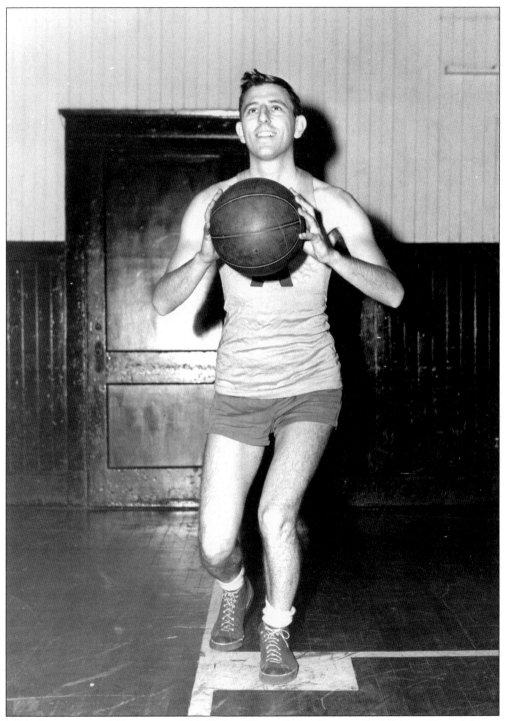

J.E.A. Basketball, 9 December 1946. Herbert Blumenthal is shown at the J.E.A. on Barnard Street, taking a shot at the basket.

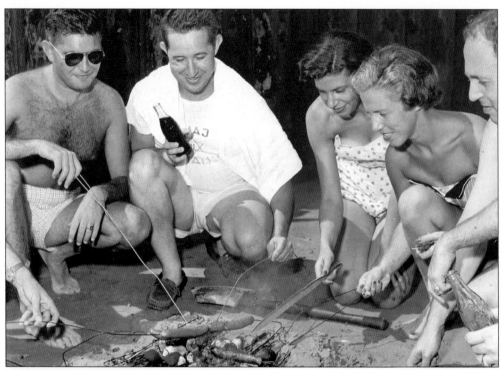

RECREATION, C. 1947. These young people seem to enjoy roasting hot dogs. From left to right are Murray Bono, Leonard Greenfield, Mae (Heyman) Lipsey, Gertrude (Hoffman) Hackman, and Willard Myers.

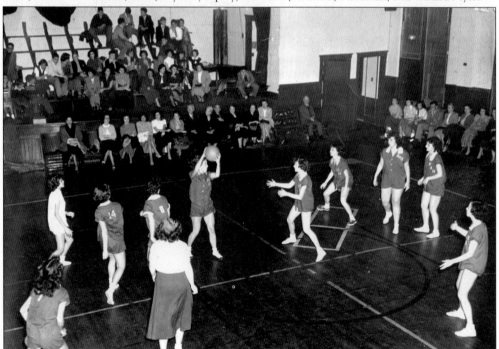

J.E.A. GIRLS' VARSITY BASKETBALL, JANUARY 1950. The J.E.A. girls' basketball team played a benefit game for the March of Dimes against the Maids of Athens.

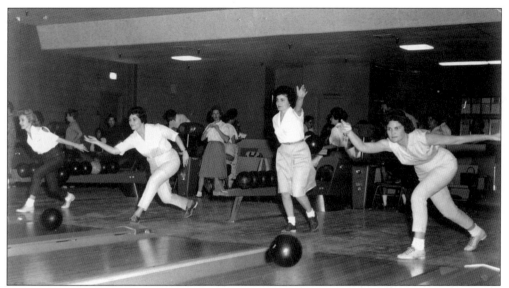

J.E.A. Bowling League, 1952. From left to right are Sylvia (Adler) Udinsky, Marilyn (Arkin) Seeman, Lillian "Mickey" (Goldman) Murphy, and Rosalyn (Weiser) Gordon, shown aiming at the pins.

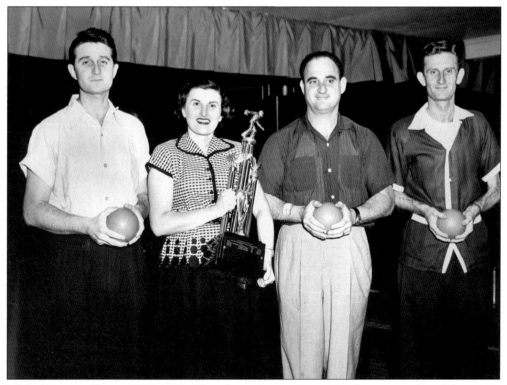

J.E.A. Bowling Team, 1952–1953. These happy league winners for the year are, from left to right, Gilbert Odrezin, Rosamae (Kaminsky) Alpert, Maurice Alpert, and David Odrezin.

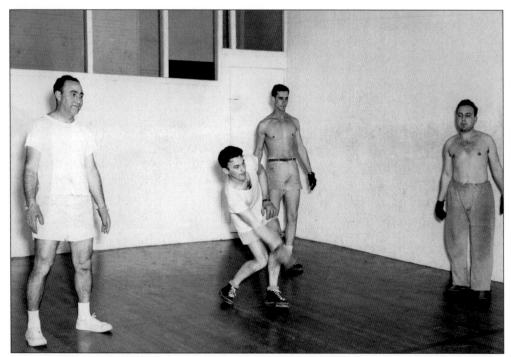

J.E.A. HANDBALL, C. 1953. Pictured from left to right, Alex Heyman, Isadore Diamond, Harry Kaplan, and Alex Scheer, share a doubles game of handball in the Barnard Street building.

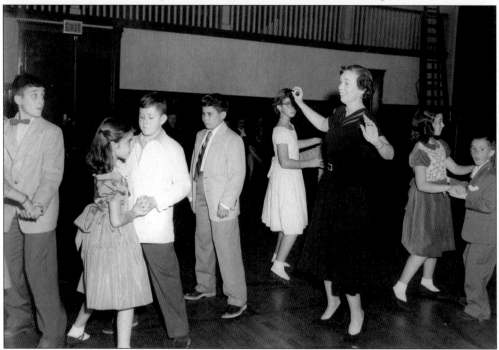

J.E.A. CHILDREN'S BALLROOM DANCE CLASS, 1952–1953. From left to right are Arthur Barnett, Ruth (Weiner) Smith Mills Blacher, Arthur Weiner, Ronald Haysman, Ida Raye (Rabhan) Chernan, Helen Marie Kenney (director), an unidentified girl, and Gary Weil.

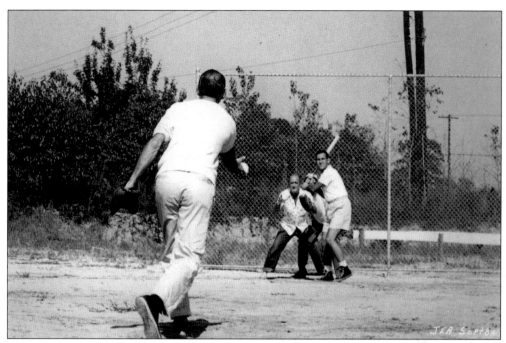

J.E.A. SOFTBALL, 29 SEPTEMBER 1956. Shown in this photograph, Harry Eichholz pitched to Walter Lowe, while Charlton Murphy served as catcher.

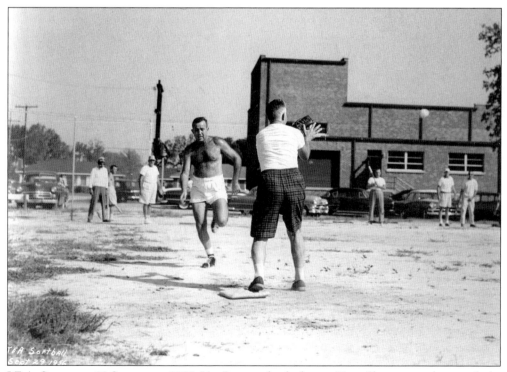

J.E.A. SOFTBALL, 29 SEPTEMBER 1956. Nat Ross ran for the base as Harry Shore got ready to catch the ball at this game behind the building on Abercorn Street.

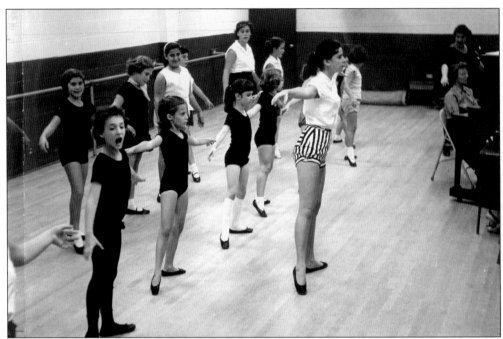

J.E.A. TAP AND BALLET CLASS, 1 OCTOBER 1956. Among those shown are Hedda (Center) Ginsberg, Iris (Diemar) Ginsberg, Judy (Waldman) Klein, Debbie (Sutker) Ewaldsen, Rochelle (Ginsberg) Husney, Brenda (Elman) Salter, Rosalie (Goldberg) Cotler (instructor), Bonnie (Stapen) Bock, Cherie (Lennox) Levitt, Renee (Wagner) Shoob, Betty Judy (Homansky) Kaye, Marsha (Tenenbaum) Kessler, and Lynn (Rabhan) Owens.

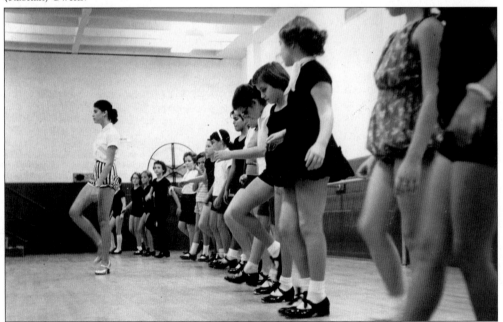

J.E.A. TAP AND BALLET CLASS, 1 OCTOBER 1956. Among those shown are Rochelle (Ginsberg) Husney, Iris (Diemar) Ginsberg, Hedda (Center) Ginsberg, Brenda (Elman) Salter, Betty Judy (Homansky) Kaye, Sara (Cantor) Wheeler, Bonnie (Stapen) Bock, and Cherie (Lennox) Levitt.

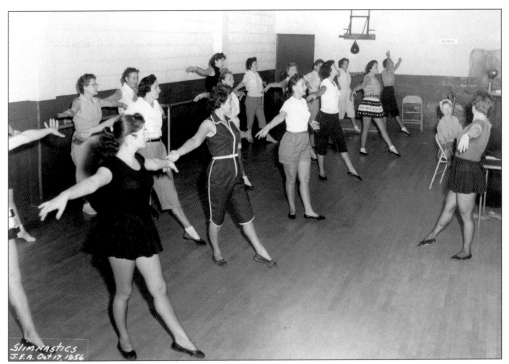

J.E.A. WOMEN'S SLIMNASTICS CLASS, 17 OCTOBER 1956. Slimnastics was a precursor to the aerobic classes now offered by the J.E.A.

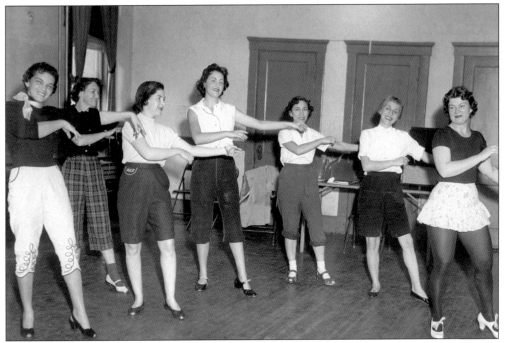

J.E.A. WOMEN'S SLIMNASTICS CLASS, 1955. From left to right are Lillian "Mickey" (Goldman) Murphy, Cecile (Richman) Barker, Betty (Adler) Nathan, Sara (Kantsiper) Switz Rigel, Minnie (Hoffman) Charnovitz, Eva (Schwarz) Odrezin, and Rosalie (Goldberg) Cotler (instructor).

J.E.A. ANNUAL GYM JAMBOREE, 27 FEBRUARY 1957. From left to right are Faye Kirschner, Pat (Friedman) Adler, Shirley (Lefko) Cohen, Diane (Garvis) Israel, Judy "Eve" (Rosenzweig) Broudy, Arlene (Kaye) Jacobson, an unidentified girl, Paula (Barker) Bower, and an unidentified girl.

J.E.A. ANNUAL GYM JAMBOREE, 27 FEBRUARY 1957. Sara (Cantor) Wheeler is shown directing the other girls.

Five

CLUBS AND ORGANIZATIONS

There are national and international Jewish clubs and organizations for everyone, male and female, young and old. In addition, many local ones have been formed by the Jewish Educational Alliance and by the local synagogues.

TORPIAN SOCIETY, 25 DECEMBER 1927. The Torpian Society was a group of young adults who had a costume party every year on the 25th of December. Most of the members were Reform Jews attending Congregation Mickve Israel.

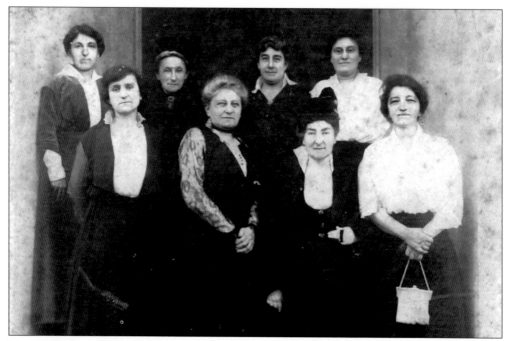

LADIES' HEBREW BENEVOLENT SOCIETY OFFICERS, C. 1916. Founded in 1853, this organization was previously called the Ladies' German Benevolent Society. It was deemed inactive by 1930, and replaced by the Hebrew Women's Aid Society. From left to right are (front row) Lily (Silverstein) Mendel, an unidentified woman, Cecelia (Bush Sheftall) Abrahams, and Leonie (Dreyfus) Levy; (back row) Rosie Hirsch, an unidentified woman, Sadie Lewis, and Ida (Boley) Byck.

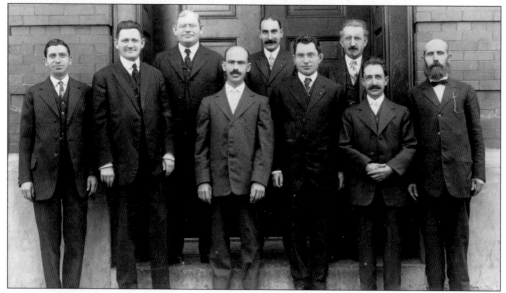

H.G.H. SOCIETY OFFICERS, C. 1916. The Hebrah Gemiluth Hesed was organized in 1888 for tzadaka (charity) and justice. The society made loans without interest to newcomers and dispensed benefits for illness and death. This photograph was taken in front of Synagogue B'nai B'rith Jacob on Montgomery Street. From left to right are Hyman Horovitz, Alexander Sutker, an unidentified man, Simon Goldin, Isaac Victor, David Weitz, Solomon Mohre, Benjamin Whiteman, and Wolf Steinberg.

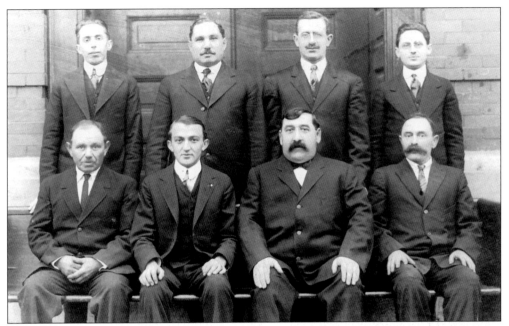

HEBREW BENEFICIAL ASSOCIATION, C. 1916. Founded in January 1907, this mutual social and benefit society provided financial assistance in cases of illness or death. From left to right are (front row) Jacob Lasky, an unidentified member, Harris Kravitch, and Joseph Greenberg; (back row) Harry Steinberg, Louis Weitz, Meyer Cherkas, and an unidentified member.

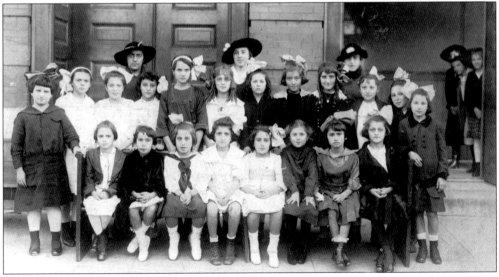

HADASSAH JUNIORS, C. 1916. A Zionist organization for women, Hadassah began operating in Savannah in October 1914. Hadassah Juniors were girls between the ages of 7 and 14. From left to right are (front row) Hannah (Rosen) Feinberg, Miriam Lewis, Pauline (Mirsky) Stein, Sara Mohre, Sarah (Greenberg) Mopper, Fannie Levine, Etta (Mirsky) Feidelson, and Rachel (Gordon) Klion; (middle row) Kate (Estroff) Malkove, Ethel Homansky, Ida (Rubnitz) Platock, Lena (Feinberg) Rosenzweig, Hannah (Nochomovsky) Tillinger, Phyllis (Goodman) Grossweiner, Edith (Peltz) Krapf, Sophie (Green) Kooden, Sophie (Sutker) Guyes, Yetta (Pollock) Siegel, Etta (Richman) Wagner, and Elizabeth Kaplan; (back row) Sadie (Lewis) Feinstein, Rachel (Gold) Levy, and Sara (Levy) Kaplan.

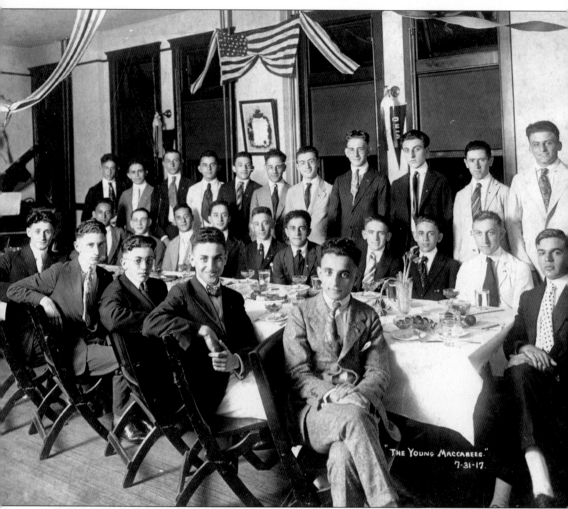

THE YOUNG MACCABEES, 31 JULY 1917. This club was formed 29 July 1913 under the leadership of Rabbi Charles Blumenthal, to promote the intellectual, moral, educational, and physical development of boys 13 to 16 years old. From left to right are (front row) Meyer Tenenbaum, Leon Singer, Matthew Levy, Selig Levi, and Barney Kahn; (middle row) Elry Stone, Ellis Blumenthal, David Feinberg, Morris Perlman, Meyer "Slim" Blumberg, an unidentified member, Louis Slotin, Jacob Gittelsohn, Samuel Goodman, and Alex Goldstein; (back row) Isadore "Zulie" Harris (nee Horovitz), W. Leon Friedman, Samuel Robinson, an unidentified member, Benjamin Sauls (nee Savilowsky), Fred Rosolio, William Silverman, Nathan Sutker, an unidentified member, Herman Siegel, and Stanley Wolf.

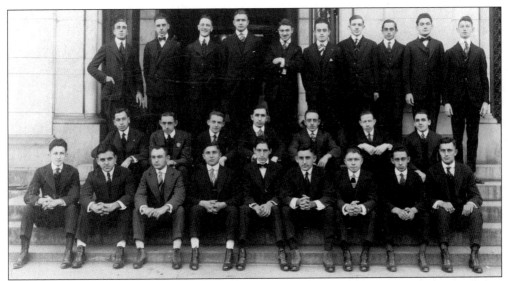

THE DON'T WORRY CLUB, 1915. This photograph was taken outside the post office, facing President Street. The social and literary club for young ladies and men was founded in Savannah 26 May 1915. Debates were sponsored by the club. From left to right are (front row) Victor Sutker, Lindy Hornstein, Fred Ehrenreich, Julius Siegel, Barney Slifkin, Samuel Hornstein, Isaac Levington, Joseph Schmalheiser, and Myer Trace; (middle row) Alexander Meddin, Emanuel Kandel, Hyman Bluestein, Harry Mays, Hyman Perlman, Ellis Blumenthal, and Sam Sauls; (back row) Nathan Orovitz, Harry Schur, Charles Jacobs, Harry Gittelsohn, Isidor Kadis, Max Gordon, Maurice Abraham, Elry Stone, Morris Rabhan, and Isadore "Zulie" Harris (nee Horovitz).

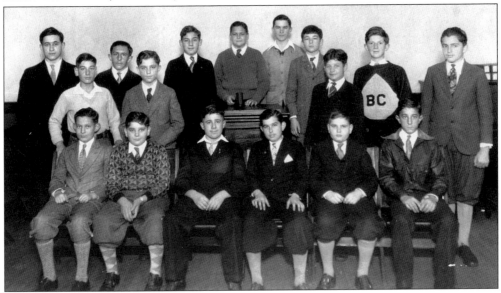

THE HERZL LITERARY SOCIETY, 1928. Named for Theodor Herzl (1860–1904), a Hungarian-born Austrian Jewish writer, who advocated the founding of a Jewish state in Palestine, this society sponsored literary debates for boys 13 to 16 years old. From left to right are (front row) Noah Ginsberg, Coleman Mopper, Jacob "Yank" Bluestein, Moses Cooper, Harold Sutker, and Milton Bellah; (middle row) Gerald Meddin, Herman "Skeeter" Itzkovitz, Sidney Asher, and Milton Lipsitz; (back row) Abram Eisenman, Lester Lasky, Milton Mazo, David Rosenzweig (president), Mickey Deich, Irvin Center, and Melvin Blair.

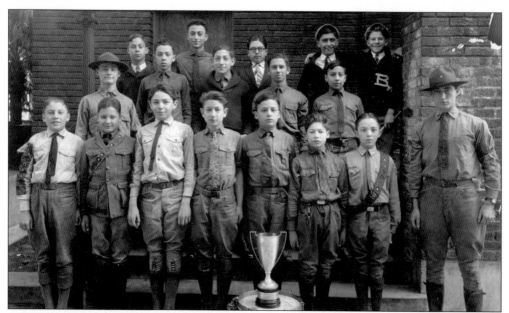

J.E.A. Boy Scouts, 27 December 1925. Boy Scout Troop #2, chartered in 1913 in Savannah, was named the best troop in Chatham County in 1922. Troop members, from left to right, are (front row) Isadore "Musky" Movsovitz, Isadore Kolman, Joseph "Brother" Wilensky, Hyman Sutker, Mike Kraft, Bernie Lennox, Harry Richman, and Abe Friedman; (middle row) Leo Blumenthal, Louis Lesser, Karl Sutker, Jerome Lewis, and A. Kraft; (back row) Lipman "Lippy" Wise, Alex Heyman, Abraham "B" Bernstein, Louis Wexler, and Bernie Slotin.

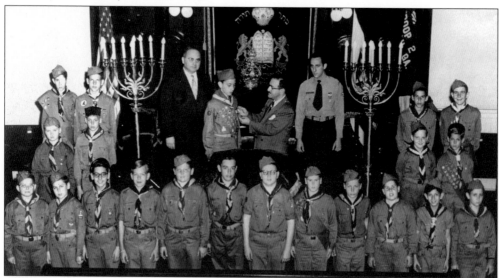

J.E.A. Boy Scouts, May 1951. This photograph, taken in the B'nai B'rith Jacob Synagogue, depicts Nathan Rabhan receiving the first Ner Tamid scout award issued in Georgia. From left to right are (front row) Tommy Blumenfeld, Robert Hirsch, Larry Pike, Arnold Tillinger, Barron Goodman, Harvey Weitz, Melvin "Mesch" Hirsch, Allan Wexler, Lawrence Movsovitz, Robert Martin, Steve Cohen, and Matthew Lybanon; (middle row) Solomon Epstein, Michael Poller, Stanley Greenfield, and Stanley "Spud" Karsman; (back row) Warren Steinberg, Herbert Goodman, Leonard Rabhan, Nathan Rabhan, Rabbi A. I. Rosenberg, William Lasky, Walter Rabhan, and Samuel Wilensky.

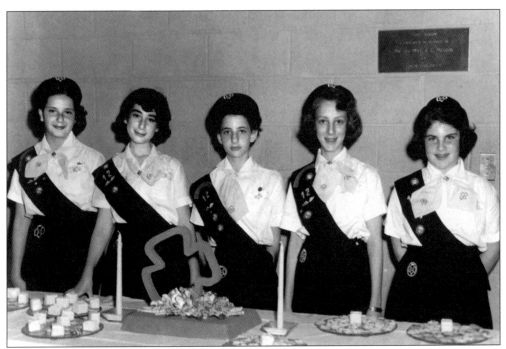

J.E.A. GIRL SCOUTS, 21 APRIL 1958. This was Girl Scout Troop #12. Juliette Gordon Low founded the Girl Scouts in Savannah in 1912. From left to right are Barbara (Jacobson) Meddin, Grace Goodove, Carol (Fleischaker) Garber, Simone (Broome) Wilker, and Debbie Cohen.

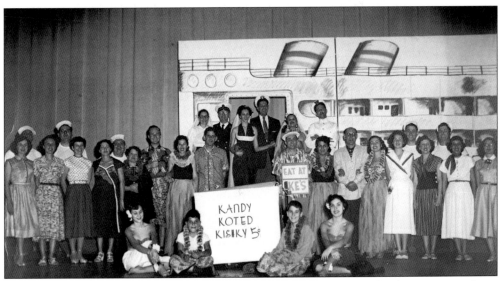

HADASSAH, 1952. Every year, Hadassah presented a variety show called *Hadassah Presents* in order to raise money

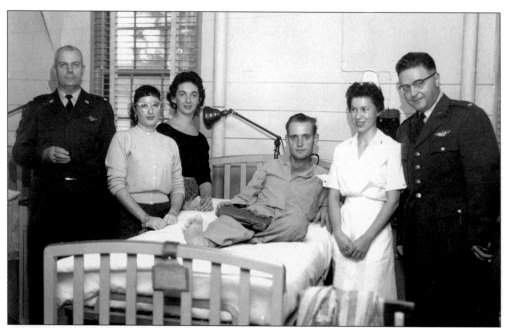

B'NAI B'RITH, 1950s. Hebrew for "Sons of the Covenant", B'nai B'rith is a social and service oriented organization. The Savannah chapter was chartered in 1860. B'nai B'rith members are shown visiting the Hunter military hospital. From left to right are an unidentified man, Mickey (Kapner) Siegel Levy, Sylvia (Adler) Udinsky, and three unidentified people.

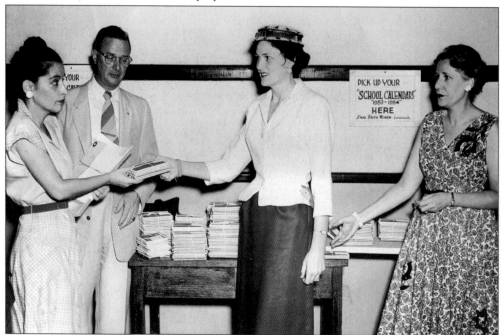

B'NAI B'RITH WOMEN, 1953. This photograph depicts two members of B'nai B'rith Women presenting calendars showing the Jewish holidays to the public schools. From left to right are Saxon Bargeron (Chatham County superintendant of education), an unidentified man, Rosalyn (Weiser) Gordon, and Dorothy (Spivak) Odess.

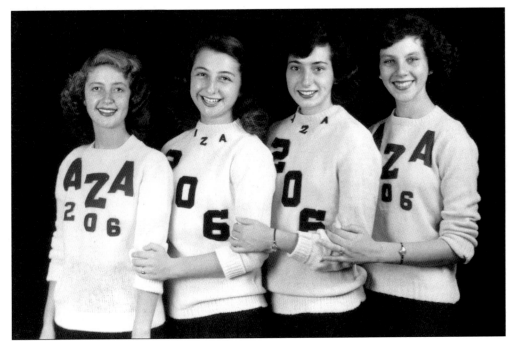

A.Z.A. Cheerleaders, 9 November 1947. A.Z.A., a social and service club, sponsored sports teams. From left to right are Cherry (Hirsch) Kutler, Sally (Mirsky) Kaplan, Betty (Kaminsky) Jacobson, and Ann (Portman) Strother.

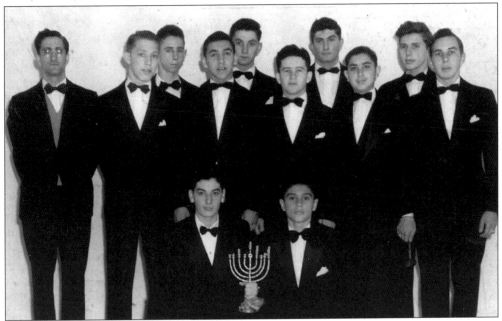

A.Z.A. Second Degree Team, 10 May 1946. Aleph Zadik Aleph, whose membership is limited to boys in grades 9–12, was adopted by B'nai B'rith. Savannah's chapter formed in 1934. From left to right are (front row) Roger "Roddy" Meddin and Erwin "Ernie" Friedman; (back row) Sanford Wexler (advisor), Philip Hoffman, Marvin Lesser, Ramon Udinsky, Gerald Pollack, Bernard "Buddy" Portman, Alan Gottlieb, Harry Robbins, Fred Wolson, and Irvin Konter.

J.E.A. CAMERA CLUB, 17 NOVEMBER 1957. From left to right are Joan (Bannett) Brown, Mitzi (Kantziper) Faurest, Gail (Alpern) Ginsberg, and Sara (Cantor) Wheeler.

DAUGHTERS OF ZION, MARCH 1952. One of many youth organizations, this one held shows, contests, debates, and other programs, such as this Israeli canteen. From left to right, in the foreground, are Robert Friedman, Judy Barnett, Linda (Homansky) Fine, Sally (Rotkow) Levine Sanders, and Charles Itzkovitz. In background: Janet (Silverman) Reed, Harriet (Weiss) Karesh, Robert Roth, Sonia (Robbins) Greenfield, Alan Platock, Edwin Feiler Jr., Arnold Tenenbaum, Heyward Fluke, Pat (Friedman) Adler, and Anchel Samuels.

ZIONIST ORGANIZATION OF AMERICA, 15 MAY 1948. The oldest and one of the largest Zionist organizations in the United States, the Z.O.A. was founded in 1897. William Hartsfield, mayor of Atlanta, was the speaker at this celebration in honor of the declaration of the State of Israel. Also pictured are Morris Horovitz, Ida (Slotin) Wilensky, Philip Bodziner, Benjamin Silverman, Jack M. Levy, Emanuel Lewis, Rabbi A.I. Rosenberg, and Abe Rabhan.

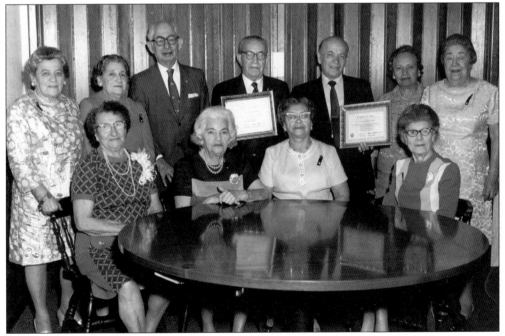

WORKMEN'S CIRCLE/ARBEITER RING, 1950S. From left to right are (front row) Bailee (Birnbaum) Dinerman, Esther Gerber, Rebecca (Shapiro) Rubnitz, and Dora (Berkowitz) Grossman; (back row) Mary (Cooper) Kaplan Swadlow, Sarah (Dunitz) Dunn, Aaron Udinsky, Sidney Paderewski, Leon Cooper, Rose (Garfinkel) Hoffman, and Annie (Udinsky) Cooper.

THE JOLLY JUDAEANS, C. 1929. The Jolly Judaeans was a social, educational, and service club for young girls. From left to right are (front row) Elaine (Gottlieb) Diamond, Mae (Heyman) Lipsey, Shirley (Cooper) Meyer, Annette (Eisenman) Alpern, Ruth (Schur) Reinhard, Harriet (Rundbaken) Rudnick, Esther (Kolman) Heyman, Sophie (Applebaum) Halperin, and Gladys (Trace) Orans; (middle row) Eunice (Cooper) Safer, Elizabeth (Eisenman) Bernstein, Rhoda (Cohen) Leibowitz, Rhoda (Galkin) Udinsky, Edith (Shoob) Karpf, Reba Wills, Lillian (Rosenzweig) Director, and Gertrude (Cooper) Safer; (back row) Jeannette (Wexler) Shiffman, Beatrice (Heyman) Goodman, Regina Segall, and Jean (Schur) Kaminsky.

YOUNG JUDAEA, C. 1952. Shown is a group of young people attending a pre-senior conclave of Young Judaea, the oldest Zionist youth movement in the United States.

Six

MILITARY

Over the years, Savannah's Jewish citizens have served in military units along with other members of the Savannah community. Besides the actual military units themselves, Jewish citizens have been involved with the auxiliaries, blood drives, plane spotting, and other military related activities.

WORLD WAR I, 1917. The caption on this photograph states, "Protectors of Democracy". From left to right are three unidentified men, Morris Buchsbaum, an unidentified man, Irving Pollack, two unidentified men, and Morris Perlman.

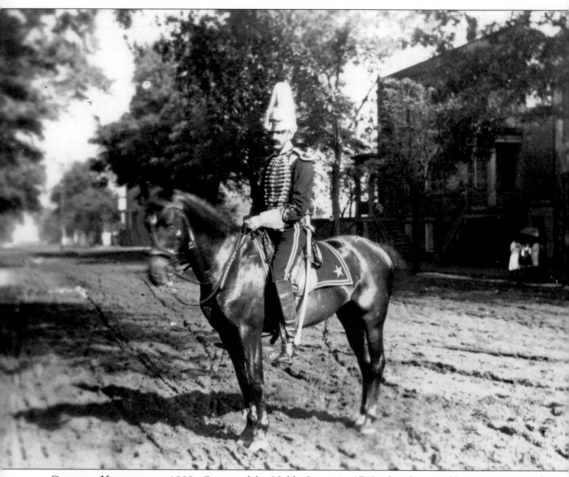

GEORGIA HUSSARS, C. 1893. Organized by Noble Jones in 1749, the Georgia Hussars represented Savannah in all wars from colonial times through 1994. Pictured here in his uniform is Abram Minis (1859–1939), descendant of one of the first families in Georgia. Minis served as an officer in the Georgia cavalry. As a lieutenant in 1893, he was among those chosen to attend the inauguration of President Grover Cleveland.

WORLD WAR I, C. 1918. Hyman Golden, who came to Savannah c. 1907, is shown in France.

WORLD WAR I, C. 1918. Pictured is Samuel Robinson, who arrived in this country with his family in 1903.

WORLD WAR II, C. 1943. David Robinson, born in Savannah in 1915, is shown (back row, second from left) at the 184th General Hospital in Fort Devens, Massachusetts. He served in the United States Army Medical Corps from 1943 to 1946.

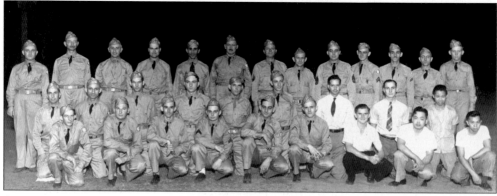

GEORGIA STATE GUARD UNIT 153, JUNE 1942. This photograph was taken in Savannah where the guard unit served. The only person of the from row who is identified is the second person from the left, Harry Shoob. The only person identified on the middle row is the second person, Norman Mirsky. The back row, from left to right, includes Norman Shoenig, Morton Levy, Samuel Robinson, Samuel Hirsch, Fred Rosolio, three unidentified people, Walter Guthman, an unidentified person, Ben Schlosser, and two unidentified people.

WORLD WAR II, C. 1943. Noah Ginsberg, born in Savannah on July 28, 1918, is shown at Fort Dix, New Jersey, in this military photograph. He served in North Africa.

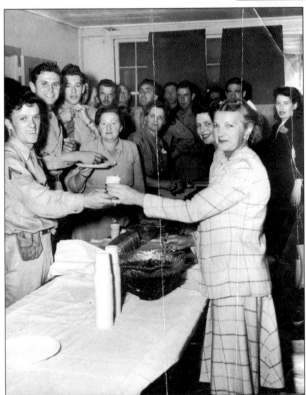

U.S.O. AT THE J.E.A., C. 1942. The United Service Organizations provides morale, welfare, and recreation services to uniformed military personnel. In this photograph from World War II, the soldiers in the back row being served sandwiches are from nearby Fort Stewart. The ladies are, from left to right, Matilda (Kaplan) Meddin, Hyla (Lewis) Hirsch, Florence Hirsch, Annie (Alpert) Alpern, and Miriam (Lewis) Boblasky.

WORLD WAR II, 1943. In this photograph taken in New York, the brothers are, from left to right, Archie, Leonard, and Martin "Maier" Rabhan.

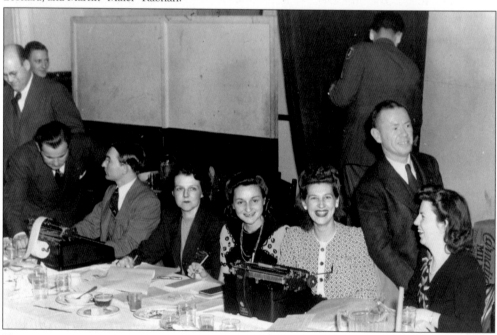

HADASSAH BOND DRIVE, FEBRUARY 1944. This bond drive was held at the DeSoto Hotel. From left to right are William Wexler, Albert Tenenbaum, four unidentified people, Herbert Buchsbaum, and an unidentified woman.

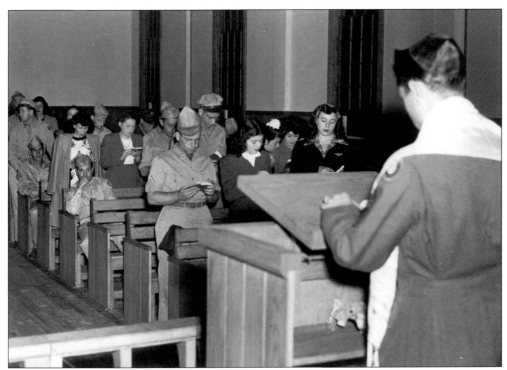

WORLD WAR II, C. 1944. Attending Sabbath and holiday services was important in peacetime and during war.

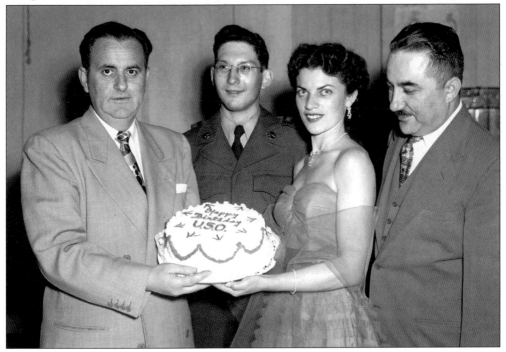

U.S.O., C. 1944. From left to right are Albert Tenenbaum, an unidentified man, Lottie Diamond, and Paul Kulick.

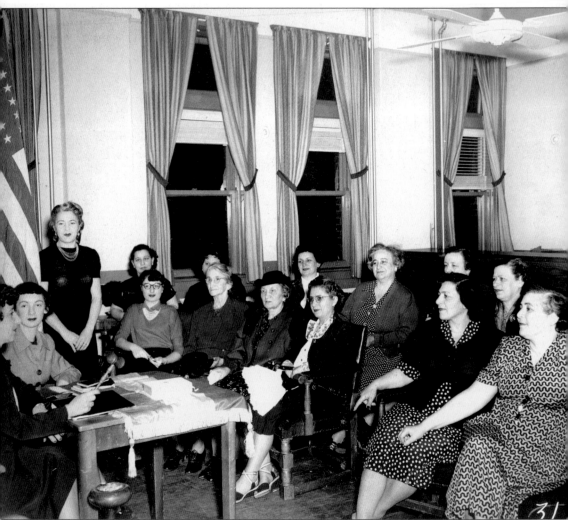

JEWISH WAR VETERANS' AUXILIARY, C. 1949. The Jewish War Veterans, begun in 1896, is the oldest active veterans' organization in the United States. Pictured from left to right are (front row) Helen (Schwartz) Perlman (president), Sylvia (Adler) Udinsky, Esther Gerber, Mickey (Kapner) Siegel Levy, Rose Green, Annie Sutker, Rose Brown, Libby Levine, and Gussie (Itzkovitz) Deutch; (back row) Faye (Davis) Funk, Reva (Kaplan) Epstein, Sylvia (Gordon) Volpin, Rae (Schwartz) Beasley, Gertrude Adler, and Mary (Cooper) Kaplan Swadlow.

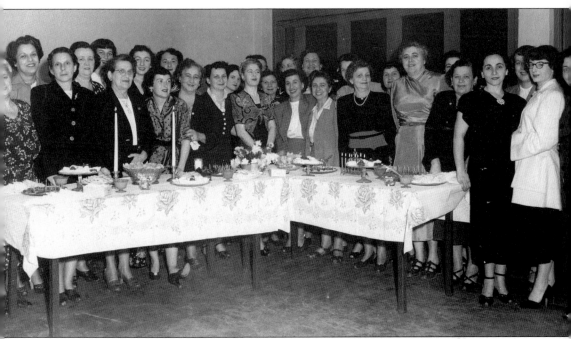

JEWISH WAR VETERANS' AUXILIARY, C. 1951. From left to right are Esther (Goldberg) Haysman, Mrs. Joe Volpin, Sara (Bradley) Goldberg, Gertrude Adler, Betty Jean (Weiser) Smithberg, Hannah (Karsman) Eichholz, Sylvia (Adler) Udinsky, Betty (Adler) Nathan, Eva Levine, Rae (Schwartz) Beasley, Sylvia (Gordon) Volpin, Estelle (Gerber) Goldberg, Lilly (Feinberg) Gerber, two unidentified people, Helen (Schwartz) Perlman, Florence (Foss) Cohen, Rose Brown, Sarah Rabinowitz, Faye Adler, ? Grunin, Mary (Cooper) Kaplan Swadlow, Mae (Sklansky) Geller, Zena (Levin) Kaplan, Mickey (Kapner) Siegel Levy, and Libby Levine.

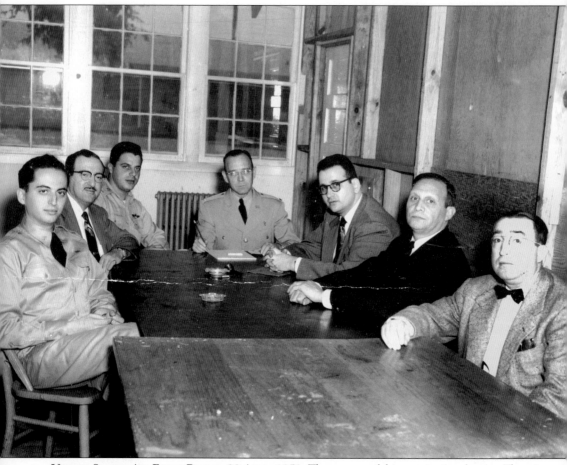

UNITED STATES AIR FORCE PHOTO, 29 APRIL 1953. The purpose of this meeting is unknown. Those in the photographs, from left to right, are an unidentified man, Rabbi A.I. Rosenberg (B'nai B'rith Jacob), two unidentified men, Irwin Giffen, Rabbi Solomon E. Starrels (Mickve Israel), and Rabbi Isidore Barnett (Agudath Achim).

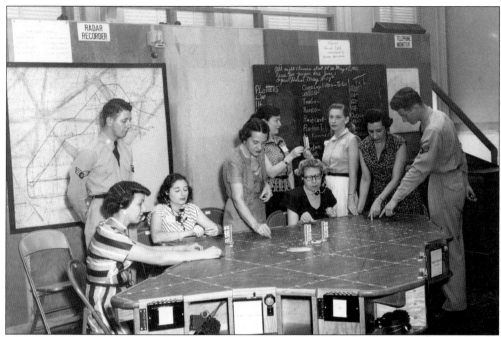

PLANE SPOTTING CENTER, 20 MAY 1953. From left to right are an unidentified woman, Zena (Levin) Kaplan, Mickey (Kapner) Siegel Levy, an unidentified woman, Ruth (Meyer) Blumberg, an unidentified woman, Audrey (Galkin) Levin, Sylvia Feuerstein, and an unidentified man.

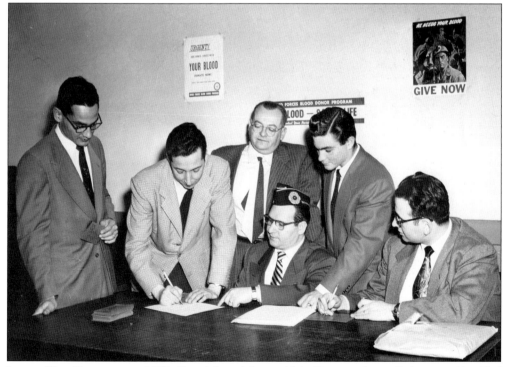

JEWISH WAR VETERANS, C. 1951. From left to right are Alvin Cranman, Lester Fodor, an unidentified man, Harry Benzel, Howard Cohen, and Irwin Giffen.

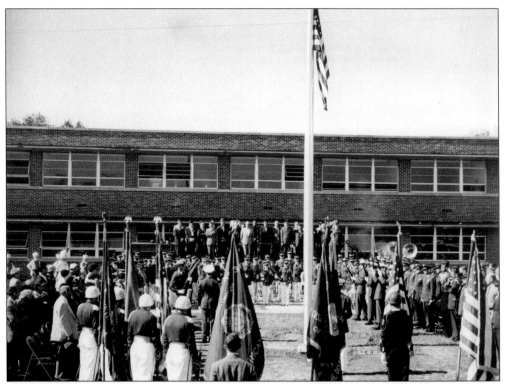

JEWISH WAR VETERANS, 11 NOVEMBER 1955. This flag pole dedication took place in front of the J.E.A. on Veterans' Day.

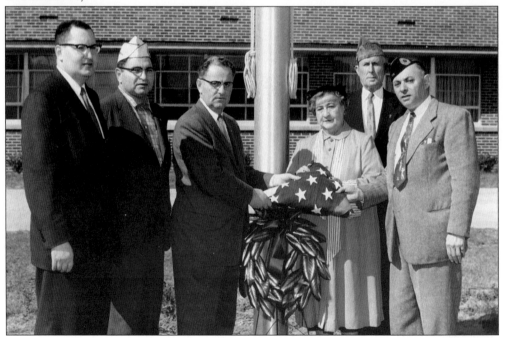

JEWISH WAR VETERANS, 11 NOVEMBER 1955. From left to right are Rabbi M. Herman Berger (Agudath Achim), Meyer Shensky, Albert Tenenbaum, Rae (Schwartz) Beasley, John Grace, and Abe Kamine.

Seven
BUSINESSES

A large proportion of Jewish citizens have been merchants throughout the years. Many of the businesses were on West Broad Street (now Martin Luther King Jr. Boulevard), Broughton Street, or in the City Market.

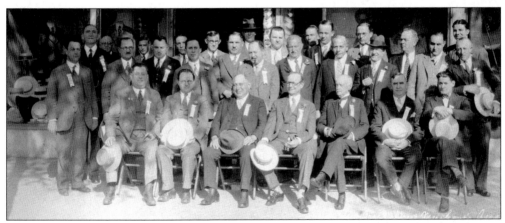

WEST BROAD STREET MERCHANTS' ASSOCIATION, 1928. The following people were identified: Ben Blumberg, Harry Marcus (also known as Dick Leonard), Frank Neuberger, Arthur Solomon Sr., Judge Peter Meldrim, Joe Harman, Mike Tenenbaum, Pete Garovitz, Charles Hirsch, Louis Pinzer, Joe Levin, Morris Shoob, Joseph Greenberg, Abe Odrezin, Louis Weitz, William Lang, Jacob Weiser, Barnard Maltinsky, Harry Blumenthal, Hyman Kanter, Gus Lipsitz, Casper Center, and Morris Perlman.

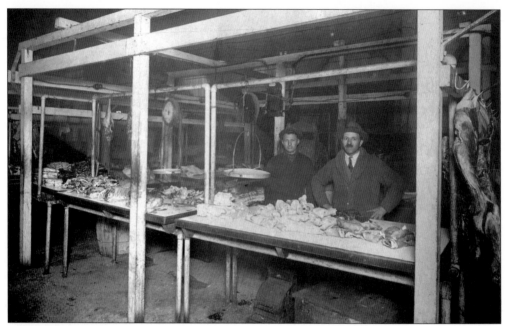

SAVANNAH CITY MARKET, 1929. The Javetz men came to Savannah in 1914, and together they operated the Javetz Meat Market in the Savannah City Market from 1923 to 1946. Pictured are Abe Javetz and his father, Juda.

TEARING DOWN OLD CITY MARKET, MARCH–APRIL 1954. Constructed in the 1870s, the old city market was the location of many Jewish businesses.

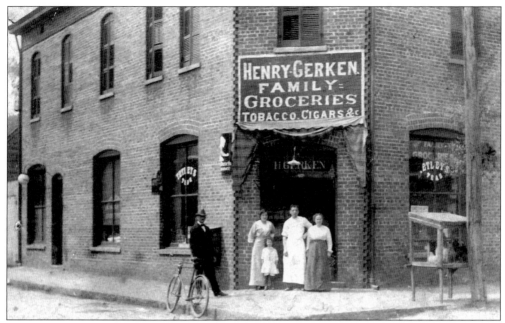

HENRY GERKEN FAMILY GROCERIES, C. 1920. Julius Weitz operated a grocery store in this location, the corner of Jones and Jefferson streets. He, his parents Abba and Mary Leah Weitz, and his siblings, lived above the store. In the early 1930s, the building was purchased and became the Crystal Beer Parlor, a popular restaurant that was operated until recently. From left to right are an unidentified man, Rachel (Weitz) Fink, Minnie (Weitz) Levy, Julius Weitz, and Ida (Weitz) Ulman.

HARRY BLUMENTHAL STORE, C. 1908. Harry Blumenthal's ready-to-wear clothing store was founded in 1907 at 414 West Broad Street. In 1914, the business became the B&B Pawn Shop, then was renamed the B&B Loan Co. in 1936. In 1946, Harry's son, Herbert, expanded the business by moving the loan company to 412 West Broad Street, placing the B&B Paint Co. at 414 West Broad Street. The original entrance tile with the name "Harry Blumenthal" can still be seen there.

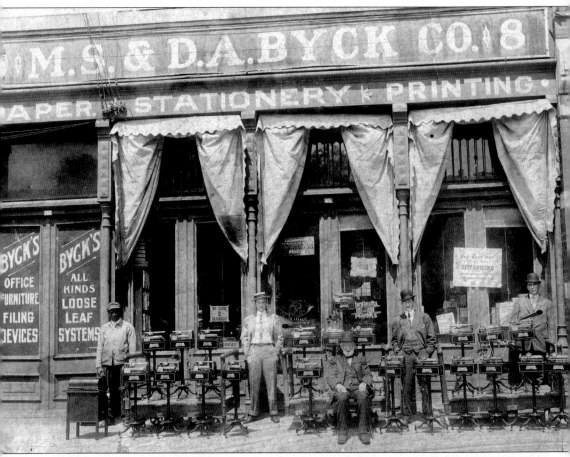

M.S. & D.A. Byck Co., c. 1921. This stationery and printing business was founded *c.* 1891 by brothers Moses S. And David Amram Byck. The business operated at 6–10 West Bay Street until the early 1930s. Pictured, from left to right, are an unidentified man, David Byck Jr., Levy Byck, Joseph Byck, and an unidentified man.

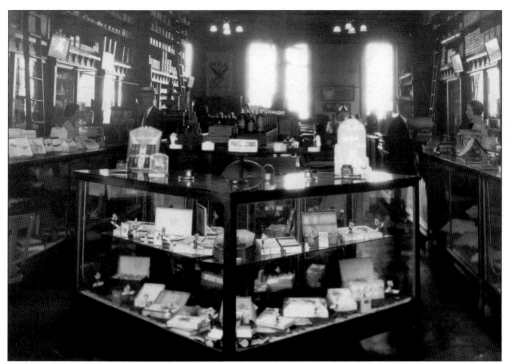

M.S. & D.A. BYCK CO., C. 1921. Clerks and customers are pictured in the stationery store.

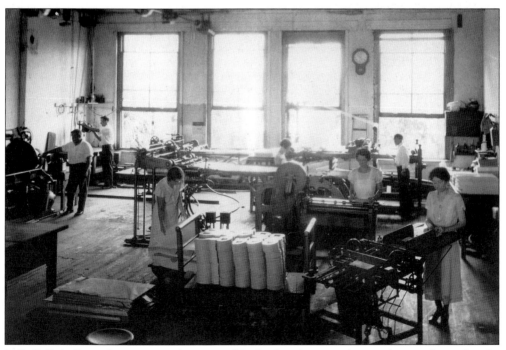

M.S. & D.A. BYCK CO., C. 1921. A section of the bindery showing ruling machines is depcited in the photograph above.

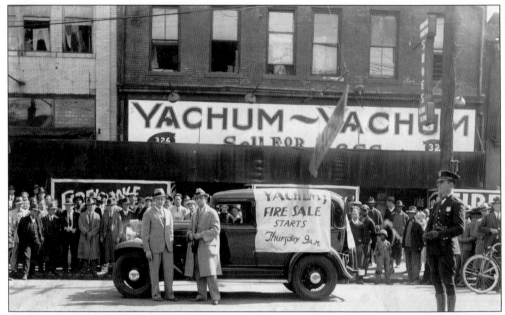

Yachum and Yachum, c. 1930. The name Yachum was adopted by Morris Perlman from a Mexican town named Yacum. This store, founded in 1910 and operated until 1968 by the Perlman brothers, was located at 324–328 West Broad Street. They sold men's, women's, and children's clothing, as well as household goods and piece goods. From left to right are Morris Perlman, Hyman Perlman, and an unidentified policeman.

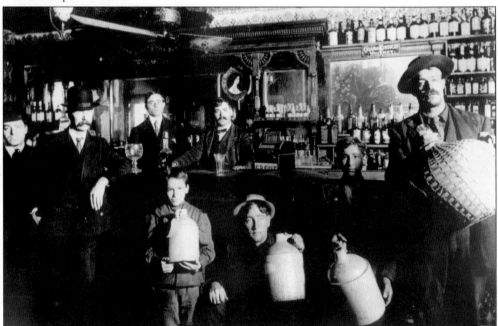

Saloon, c. 1900. Opened in the 1880s and operated until *c.* 1905 by Dan Schwartz, this saloon was located downstairs at 408 East Broughton Street. From left to right are Ferry Wheeler Sr., Mr. Haggarty, an unidentified man, Yank Schwartz, Dan Schwartz (proprietor), Frank Brown, Charles Schwartz, and Lovie Pitts.

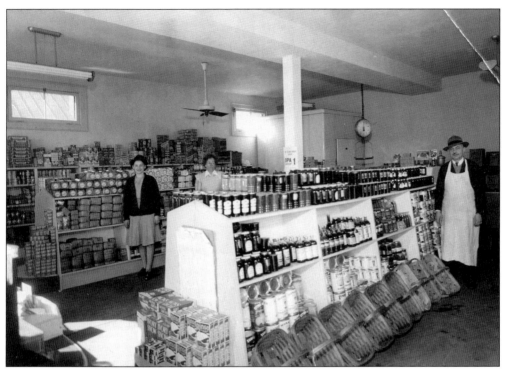

GEORGIA MARKET, 1940S. The Ginsbergs owned and operated this store, located at 701 Harmon Street, from 1939 until 1960. They lived upstairs with their three daughters until 1949. From left to right are Irma (Eichholz) Ginsberg, Miss Ruby (surname unknown), and Harry Ginsberg.

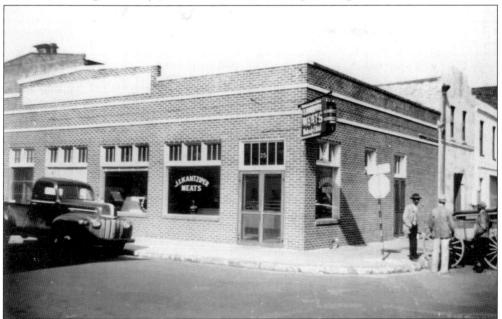

J.I. KANTZIPER MEATS, 1946. In 1925, Jacob Isaac Kantziper began selling wholesale and retail meat and other provisions in the City Market. In 1946, he moved the business to the pictured location, 25 Jefferson Street, where his operation continued until his death in 1953.

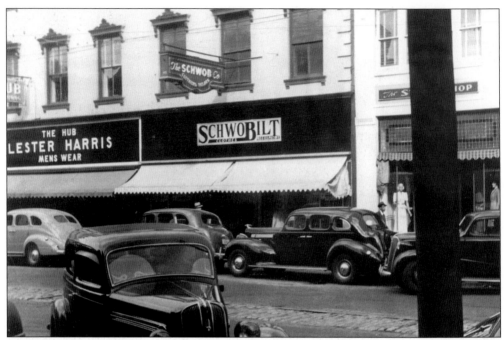

HARRIS THE HUB, 1940S. Lester Harris bought this mens' and boys' clothing business, located at 28 West Broughton Street, from Ben S. Levy in 1918. His son Stanley owned and operated the business from 1947 until 1980, at which time the store was leased to Harold Heyman and run as Heyman and Son.

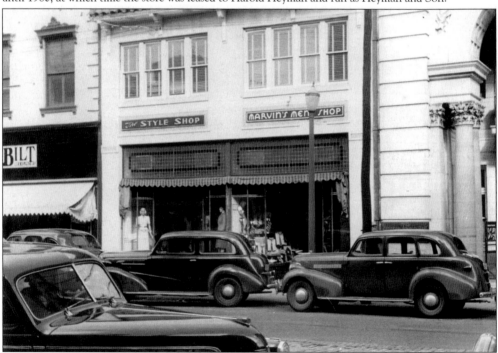

THE STYLE SHOP, 1940S. Harry Reiner founded the Style Shop in 1939 at this address, 23 East Broughton Street, where he sold ladies' clothing. The business later moved to 111 Bull Street, then to the DeRenne Shopping Center, where it closed in 1980.

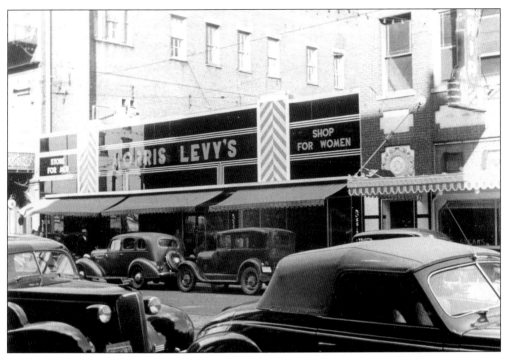

MORRIS LEVY'S, 1940S. This ladies' and mens' clothing store was located at 10–12 East Broughton Street. Morris Levy owned and operated the store from the founding date, *c.* 1924, until 1956.

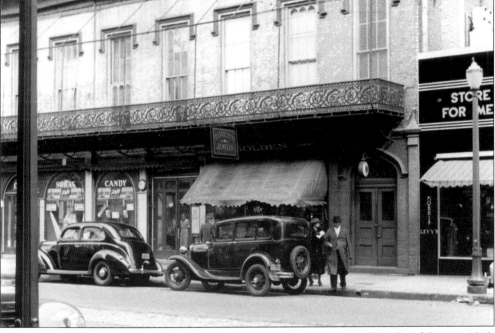

M. GOLDEN, 1940S. Mitchell Golden began operating a jewelry store at 327 West Broad Street *c.* 1910, soon after his arrival in this country. Twenty years later, Mitchell's son, Hyman, took over the business and moved it to this location, 8 East Broughton Street. By the late 1940s, the store moved again, this time to 112 Bull Street.

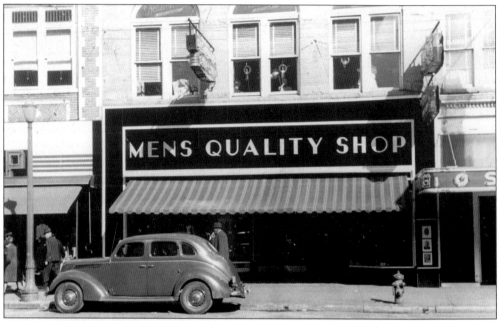

MENS QUALITY SHOP, 1940S. In the 1930s, Joseph Lesser established the Mens Quality Shop at 22 West Broughton Street, later moving to 24 East Broughton. The store carried mens' clothing, furnishings, and shoes, as well as ladies' sportswear. Eventually, the business expanded into the building next door, and Joseph's son, Marvin, took over the operation until the business closed in 1988.

CHASKIN'S, 1940S. This shop, founded by Al Chaskin in the mid-1940s, which carried ladies' clothing and accessories, was located at 121 East Broughton Street. When Al Chaskin died in the 1970s, his widow Beatrice took over the operation until her retirement in the mid-1980s.

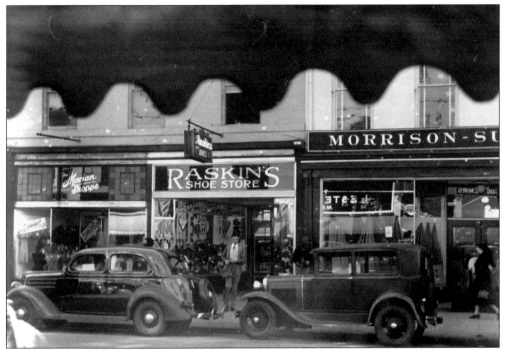

RASKIN'S SHOE STORE, 1940S. Alex, Isaac, and Robert Raskin founded Raskin's Shoe Store in 1925. Located at 23 1/2 West Broughton Street, the business continued in operation until 1948.

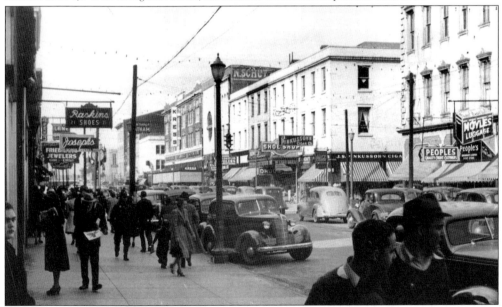

JOSEPH'S, FRIEDMAN JEWELERS, 1940S. Joseph "Brother" Wilensky operated Joseph's, a ladies' dress shop, from 1939 to 1950, at 25 West Broughton Street. Farther down the street is Friedman Jewelers. B.I. Friedman and his family opened a jewelry store in the 1920s, soon giving it the name Friedman Jewelers. After various other places, the store finally moved to the 101 West Broughton Street location shown here. B. I. Friedman's sons, Stanley and Herman, later ran the store, opening several branches. They sold the business in 1990.

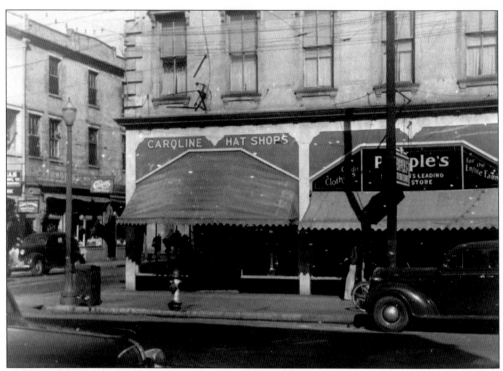

CAROLINE HAT SHOP, 1940s. Located at 36 West Broughton Street, this business was owned and operated by Samuel Bodziner from around 1930 until the middle 1940s.

STANLEY JEWELERS, 1940s. Stanley Jewelers was founded by B.I. Friedman in the late 1940s, at 21 East Broughton Street. It was operated in a similar fashion to Friedman Jewelers.

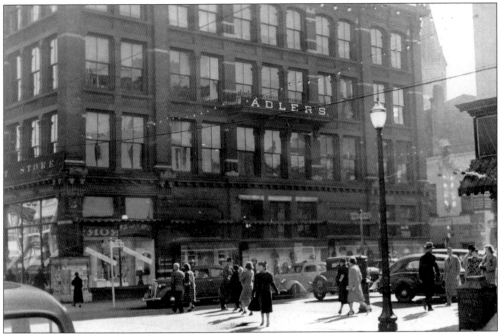

ADLER'S, 1940S. In 1878, Leopold Adler purchased Altmayer's Department Store on the corner of Broughton and Bull Streets, renaming it Adler's Department Store. In the 1950s, Leopold's son, Sam G. Adler, took over the business. By 1959, Sam G. Adler Jr. owned the business, which he moved to two other locations. The store in the Victory Drive Shopping Center eventually closed, but the one at Oglethorpe Mall remained in business until it was liquidated in 1985.

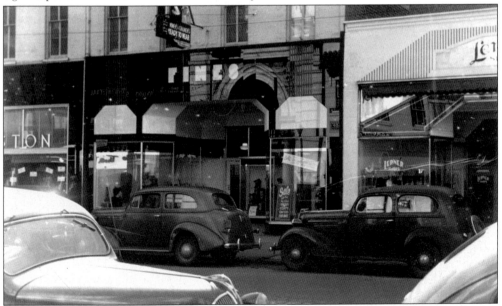

FINES, 1940S. In the early 1930s, Jacob Fine Sr. opened a women's clothing business at 209 West Broughton Street. By 1937, the store had relocated to 15 West Broughton Street, as pictured above, and Jacob expanded his line to include children's clothing. His son, Jacob Fine Jr., joined the business after World War II. The business was eventually sold and moved to Oglethorpe Mall, where it closed in 2002.

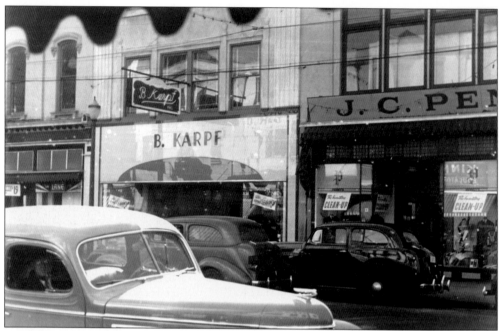

B. KARPF, 1940s. Benjamin Karpf founded this women's clothing business *c.* 1910 at 354 West Broad Street. It later moved to this location, 107 West Broughton Street. Louis Silverman owned and operated the business from 1962 until 1976.

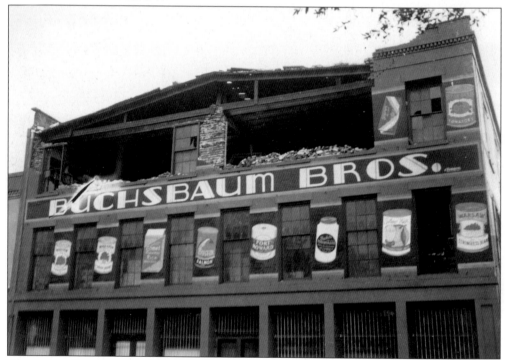

BUSCHBAUM BROS., EARLY 1940s. This wholesale grocery store, owned and operated by Herbert and Frank Buchsbaum from 1928 to 1950, was located at 6 Barnard Street. The photograph shows the building soon after it had been damaged by a hurricane.

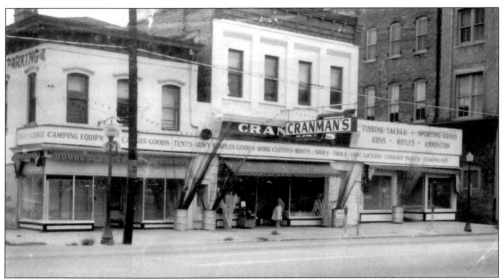

CRANMAN'S, 1955. Purchased by Edward Cranman in 1947, the store was originally a pawn shop and then sold sporting goods from 1958 until 1980. It was located at 345, then 223, West Broad Street.

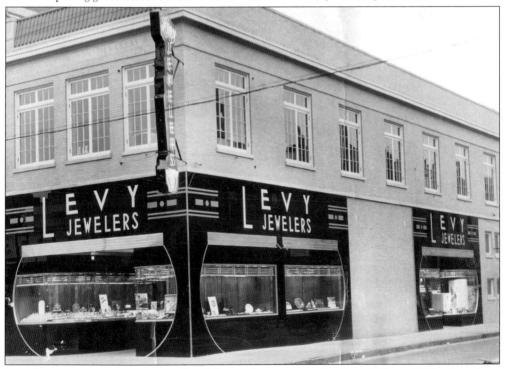

LEVY JEWELERS, 1940s. Aaron Levy founded a jewelry store named A. Levy & Son at 20 East Broughton Street, soon after the turn of the 20th century. For a short time, he also operated a store in another location, at 211 West Congress Street. When Aaron Levy died in 1929, his son, Jack M. Levy, took over the business on Broughton Street, which at various times was at 18, 20, and 25 East Broughton. The store finally moved in 1937 to 101 East Broughton Street, the current location, and in 1941 was renamed Levy Jewelers. The business is now owned and operated by Aaron Levy (grandson of the original Aaron) and his wife, Dayle.

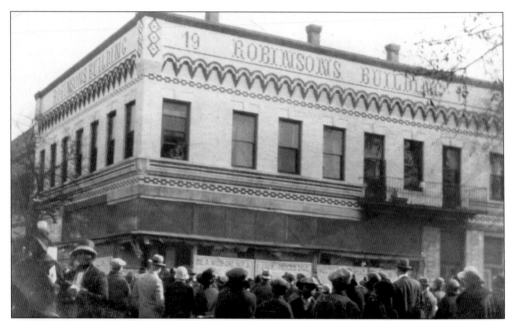

ROBINSONS BUILDING, 1912. Located on the corner of Park Avenue and West Broad Street, this photograph was taken at the grand opening of the Robinsons Building. The building was owned by Elias and Clara (Mirsky) Robinson, who lived upstairs with their children and operated a dry goods business downstairs. The name of the store, written in brick, is still visible on the second floor on both sides.

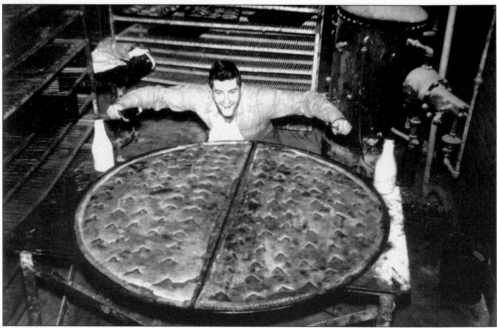

GOTTLIEB'S BAKERY, C. 1953. Pictured is the largest apple pie ever baked. Gottlieb's Bakery was established and operated by Isadore Gottlieb from 1884 until 1934, then run by Elliott and Irving Gottlieb until 1982. Isser Gottlieb was the last family member who operated the bakery, running it until 1994 when it closed. It was located at 1601 Bull Street. Previous locations were York and Jefferson Streets, Bryan and Montgomery Streets, Oglethorpe Avenue and Montgomery Street, and 519 East Broughton Street.

Eight

ENTERTAINMENT AND SPECIAL EVENTS

Along with the serious topics pictured in this book, we now present the ones that we especially like to remember—life-cycle events, plays, dances, and musicals.

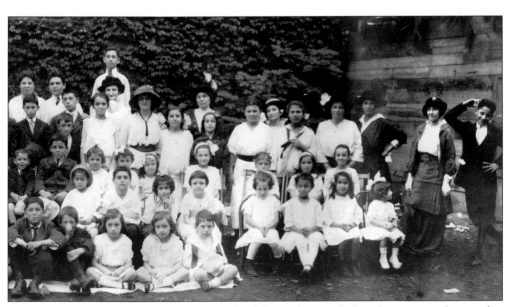

SUCCOTH FESTIVAL, 5 OCTOBER 1914. Succoth celebrates the period when the crops were harvested in ancient times. The family eats in a succah, or booth, set up outside. The celebration in this photograph was held by the Hebrew School of Congregation B'nai B'rith Jacob, with Rabbi Charles Blumenthal as superintendent.

TIVOLI GUARDS, 1898. Pictured is Edgar L. Wortsman, Captain of the Guards. The Tivoli Guards, composed of boys from 9 to 13 years of age, under the command of Capt. Edgar L. Wortsman, was organized 1 June 1895. Their main objective seemed to be marching in uniforms to music. Most members were German Jews.

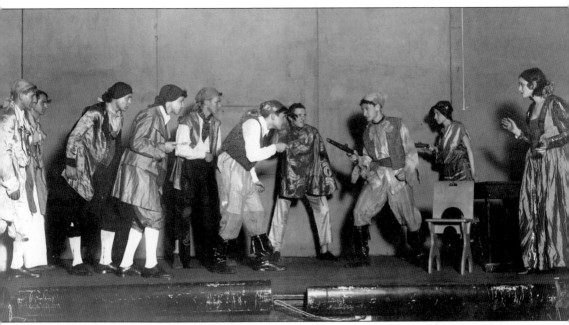

PIRATE PLAY, 15 APRIL 1931. A group of adults put on this play, *Captain Applejack,* at the J.E.A. From left to right are Beryl Bernstein, Emanuel Fialkow, Hyman Kirschner, Harry Kaplan, Jacob Grauer, Abram Eisenman, Jacob Homans (nee Homansky), Hyman Sutker, Sophie (Sutker) Guyes, and Muriel (Aarons) Sutker.

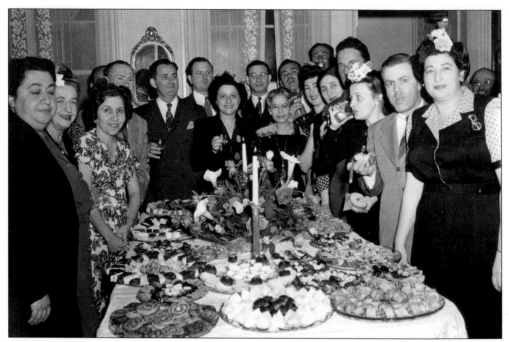

BAR MITZVAH, APRIL 1944. Bar Mitzvah is the ceremony at which a 13-year-old boy officially becomes a member of the congregation. Bas or Bat Mitzvah is the equivalent ceremony for girls. Pictured are the guests at Aaron Buchsbaum's Bar Mitzvah. From left to right are ? Kaminsky, Ida (Levy) Barnett, Dorothy Katz, Herbert Buchsbaum, Albert Tenenbaum, an unidentified guest, Ernestine Kaminsky, an unidentified guest, Anne (Lewis) Buchsbaum, Ralph Tenenbaum, Pauline (Waldman) Tenenbaum, an unidentified guest, Pearl Levy, an unidentified guest, Mildred (Goodman) Rosen, Raymond Rosen, and Rosaline (Levy) Tenenbaum.

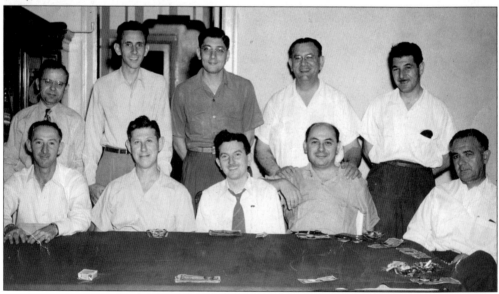

POKER GAME, 1940. From left to right are (front row) Ben "Corky" Alpert, Isadore "Izzy" Itzkovitz, David Segall, Meyer Sherman, and Mose Blumenfeld; (back row) an unidentified man, Hyman Roth, William Cohen, Max Hornstein, and George Kapner.

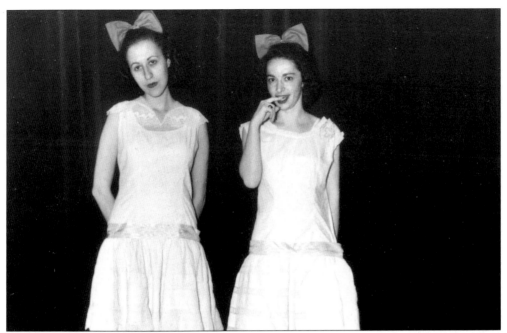

J.E.A. WOMEN'S CLUB SHOW, 25 MARCH 1947. The women in this photograph celebrated the J.E.A. Women's Club silver anniversary by dressing in costumes that they wore when they were in a fashion show at the age of 10. Louise "Sister" (Gordon) Rudofsky Zacks is on the left and Gladys (Trace) Orans is pictured on the right.

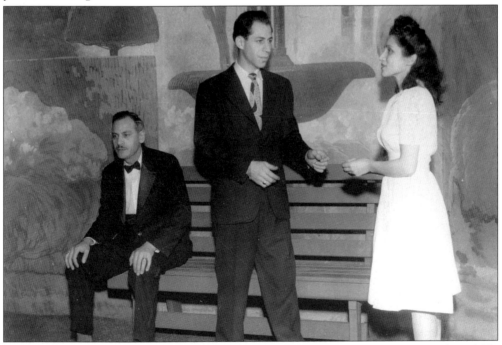

J.E.A. ADULT DRAMA CLUB, 31 JANUARY 1946. The Alliance Players of the J.E.A. performed *The Adding Machine* in the Armstrong Junior College auditorium. From left to right are Louis Black, Lawrence Wagger, and Pauline Rossi (the wife of the drama coach).

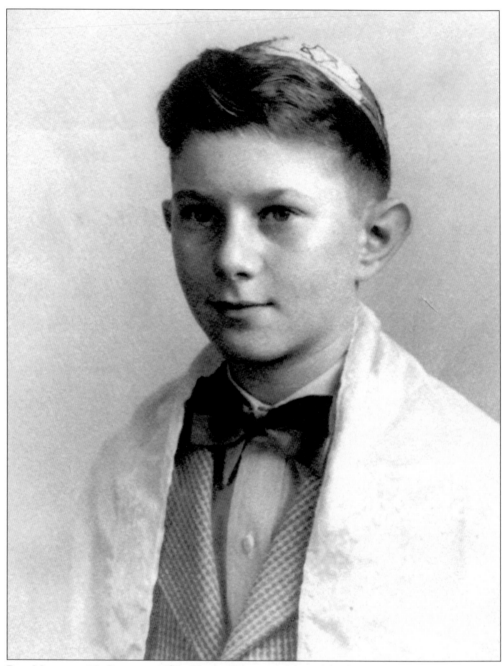

BAR MITZVAH, 25 OCTOBER 1947. Charles Itzkovitz celebrated his bar mitzvah at the B'nai B'rith Jacob Synagogue.

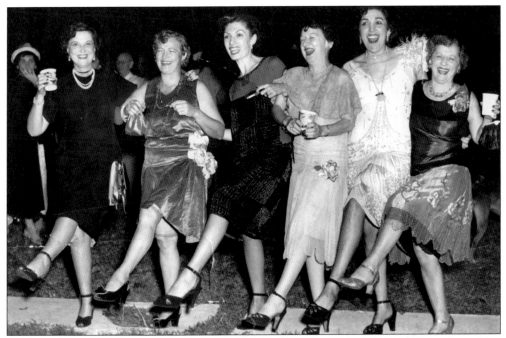

LADIES' NIGHT OUT, C. 1948. Caught kicking up their heels, these ladies were enjoying a night out on the town. From left to right are Annette (Hirsch) Schlosser, Matilda (Kaplan) Meddin, Nora Reiner, Mary (Brown) Kleinberg, Helen (Davidson) Blumenfeld, and Pearl (Robinson) Stemer.

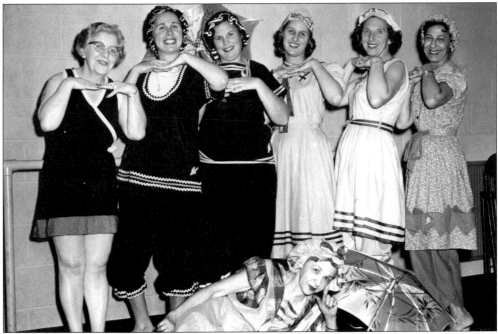

J.E.A. VARIETY SHOW, 1950s. These bathing beauties are shown dressed up for the J.E.A. variety show. From left to right are (front row) Mildred (Goodman) Rosen; (back row) Clara (Kronstadt) Galin, Evelyn (Center) Goldberg, Fannie (Center) Kramer, Barbara (Rabhan) Kooden, Jeanette (Prystowsky) Rabhan, and Helene (Karsman) Movsovitz.

J.E.A. Teen Dramatics, c. 1953. The J.E.A. sponsored plays for both youth and adults. From left to right are Sonia (Robbins) Greenfield, Naomi (Adler) Persse, Rosalind Homansky, an unidentified actor, Bette Jo (Blumenfeld) Krapf, and an unidentified actor.

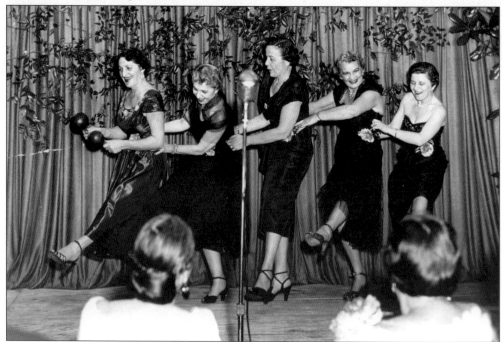

Hadassah Presents, 1950s. Hadassah, as a fund-raiser, presented a variety show annually. From left to right are Hilda (Perlman) Weiner, Mina (Mazo) Levington, Flo (Slifkin) Gordon, Matilda (Kaplan) Meddin, and Ethel (Segall) Itzkovitz.

114

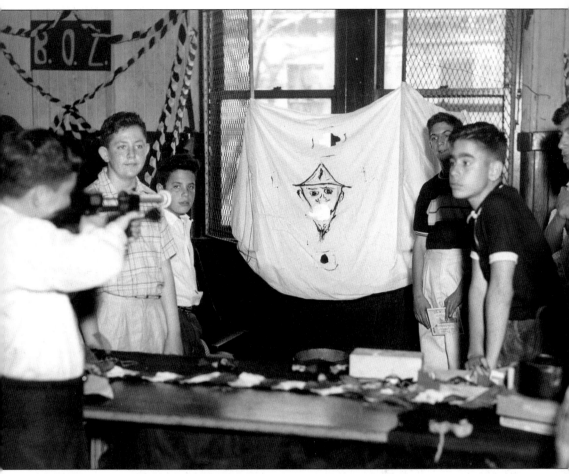

Purim Carnival, c. 1953. Purim commemorates the rescue of the Jews of Persia from Haman's plot to exterminate them. A carnival is held annually. From left to right are Joseph Marcus, Arthur Weiner, Joel Homansky, Alan Barry Kantsiper, Harvey Weitz, and Gilbert Kulick.

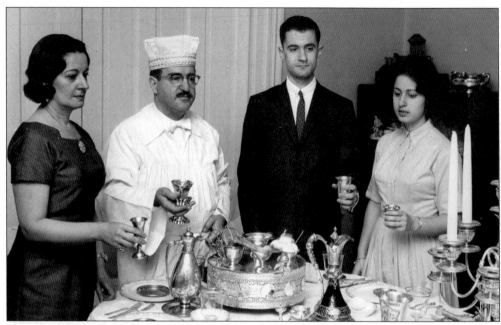

PESACH, 1950S. The Rabbi of Congregation B'nai B'rith Jacob and his family sanctify the wine in celebration of Pesach, also known as Passover, which commemorates Israel's deliverance from enslavement in Egypt. From left to right are Sylvia Rosenberg, Rabbi A.I. Rosenberg, Jules Rosenberg, and Judy (Rosenberg) Becker.

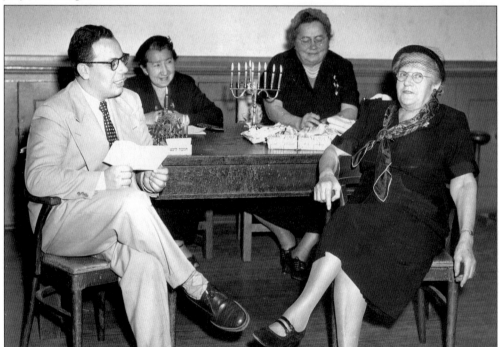

CHANUKAH PARTY, C. 1953. The Golden Agers celebrated Chanukah at the J.E.A. Chanukah, or Feast of Lights, commemorates the victory of the Jewish Maccabees over Syrian despots. From left to right are Earnest Siegel (program director), Edith (Green) Fodor, Fannie (Ehrenfeld) Rabhan, and Tillie Simon.

116

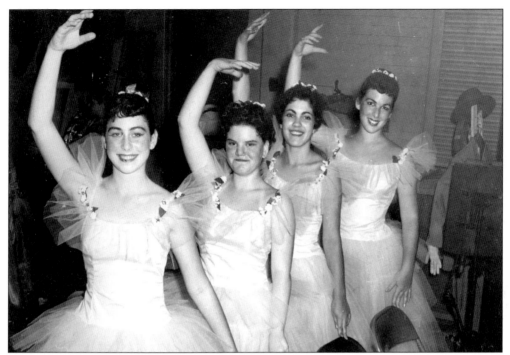

DANCE RECITAL, 20 MAY 1955. From left to right are Mickey (Ginsberg) Katz, Vicki Epstein, Phyllis Kaye, and Ida Raye (Rabhan) Chernan.

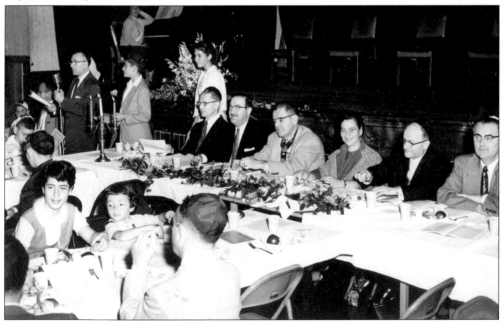

PESACH, 3 APRIL 1955. This pictures the celebration of a model seder, the meal that is traditionally eaten for Pesach (Passover). Pictured from left to right at the head table are an unidentified person, Robert Kantor, Samuel Rosenberg, an unidentified person, Claire Holzer, Cantor Eugene Holzer (Agudath Achim), Rabbi A.I. Rosenberg (B'nai B'rith Jacob), Meyer Tenenbaum, Helen Roth, Cantor Albert Singer, and Albert Tenenbaum.

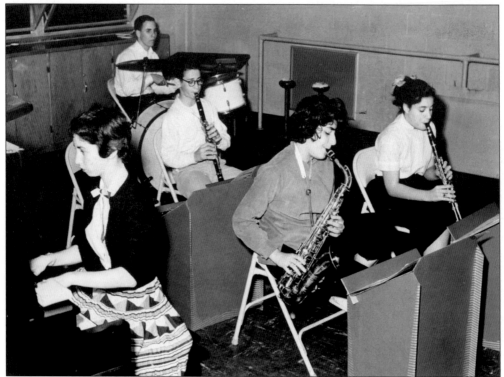

YOUTH ORCHESTRA, C. 1955. From left to right are Anita Homansky, Larry Garvis (on drums), Robert Martin, Sima Cooperman, and Debbie Cooperman.

J.E.A. TWEEN DRAMATICS, C. 1955. Clockwise from the far left are Joseph Killorin (director), Alan Weinstein, Beverly Bernstein, Sidney Kaminsky, Linda (Rosen) Palefsky Cranman, Maury Finkelstein, Lois Homans, Roberta Diemar, Stuart Rudikoff, and Charlotte (Murphy) Weitz.

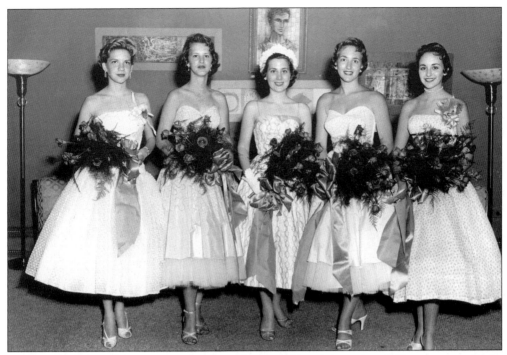

BALLYHOO, 1955. Ballyhoo was an annual social event held in Atlanta during Christmas vacation for Jewish singles from the southeast. This photograph was taken at the Standard Club. From left to right are Jackie Rose, Penny Block, Carole (Jackson) Cohen (queen of Ballyhoo), Sandra Stein, and Judy Salzberg.

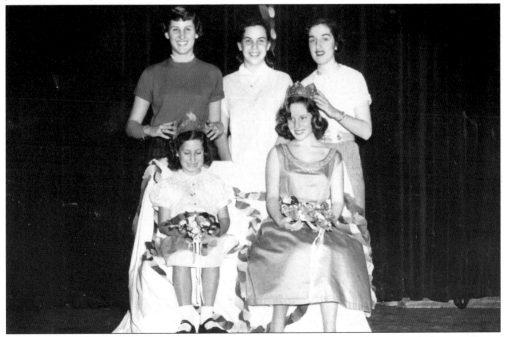

PURIM CARNIVAL, 1951. The two girls in the front row are being crowned as junior and senior Queen Esther. From left to right are (front row) Sally (Karpf) Krissman and Rebecca Marcus; (back row) Barbara (Rabhan) Kooden, Carol (Sherman) Allen, and Judy Barnett.

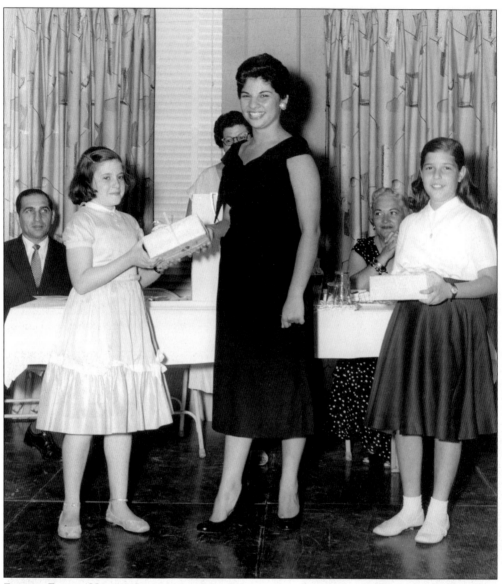

ZIONIST FAMILY NITE, 7 JUNE 1956. From left to right are (front row) Ellen Schneider, Barbara (Portman) Meyer, and Alexis Brown; (back row) Benjamin Portman, Rosaline (Levy) Tenenbaum, and Sarah Gottlieb.

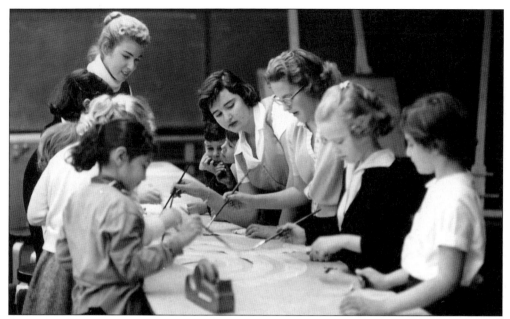

CHANUKAH PLANNING, 8 DECEMBER 1957. Among those pictured are Ida Raye (Rabhan) Chernan, Arlene (Gottlieb) Jaffie, Elsa Brueck, and Jane (Heyman) Newman.

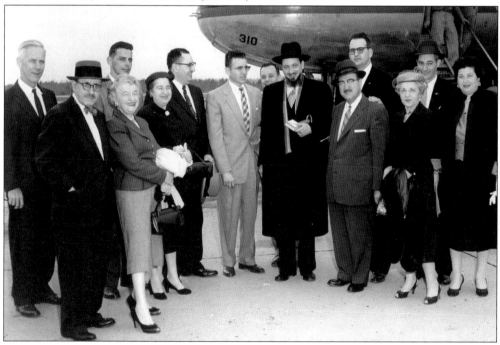

CHIEF RABBI OF IRELAND, 27 FEBRUARY 1957. This welcome committee came to greet the Chief Rabbi of Ireland. Pictured from left to right are Frank Rossiter (mayor pro-tem), Abe Tenenbaum, an unidentified person, Ida (Levy) Barnett, Sarah (Levy) Buchsbaum, Rabbi M. Herman Berger (Agudath Achim), Irving Metz (Chamber of Commerce), Earnest Siegel (J.E.A. program director), Dr. Immanuel Jakobovitz (Chief Rabbi of Ireland), Rabbi A.I. Rosenberg (B'nai B'rith Jacob), Irwin Giffen (J.E.A. executive director), Mina (Mazo) Levington, Joseph Goldberg, and Rosaline (Levy) Tenenbaum.

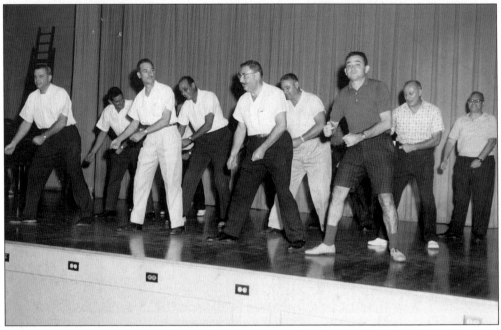

J.E.A. VARIETY SHOW, C. 1957. From left to right are Melvin Arnstein, Harold Seeman, David Dinerman, Robert Gordon, Louis Cranman, Melvin Siegel, Max Levin, Allan Cotler, and Harry Benzel.

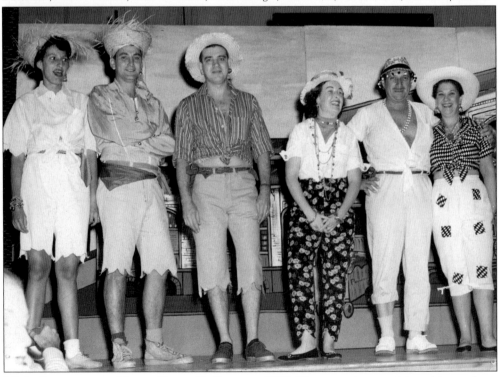

J.E.A. PARTY OF THE MONTH PLAN, 19 OCTOBER 1957. These members participated in a calypso dance. From left to right are Riette (Rabhan) Pollack, Gerald Pollack, Jacob Lang, Betty (Adler) Nathan, Julius Rudikoff, and Zelda (Wetherhorn) Homans.

J.E.A. GAME ROOM, 1957–1958. From left to right are Arthur Geffen, Richard Halperin, Robert Segall, Melvin Haysman, Marvin Waldman, Irvin Seeman, Abro Sutker, Samuel Sutker, Sandra (Kantsiper) Goodman, Barry Stoller, and Jack Sussman.

CHANUKAH CONTEST, 17 DECEMBER 1957. The nature of this contest is unknown, but the winners were the members of Brownie Troop #115. From left to right are (front row) Sharon (Birnbaum) Goldblatt, Karen Blumberg, and Marsha (Elman) Bernstein; (back row) Ilene (Levin) Friedman, Carla Kramer, Nancy (Asher) Bracker, Lynn (Rudikoff) Berkowitz, Jean Kramer, and Susan Blumberg.

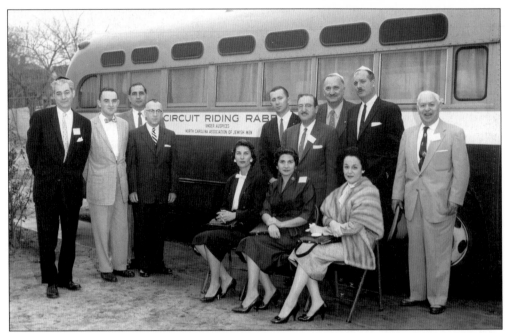

SOUTHEASTERN REGION U.O.J.C.A. CONVENTION, 1958. This photo of the Southeastern Region Convention of the Union of Orthodox Jewish Congregations of America was taken in Charleston, South Carolina, but pictures Savannah people. From left to right are (seated) Frances (Hornstein) Goldberg, Pearl (Maltinsky) Portman, and Regina "Jeannie" (Berman) Asher; (standing) Joseph Goldberg, an unidentified person, Benjamin Portman, Samuel Rosenberg, an unidentified person, Rabbi A.I. Rosenberg, Abe Rabhan, Julius Asher, and an unidentified person.

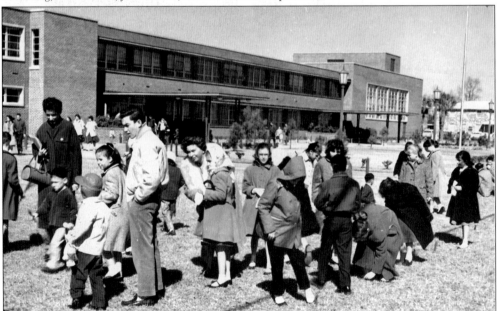

TU B'SHEVAT, 2 FEBRUARY 1958. A Jewish arbor day, Tu B'Shevat is celebrated by planting trees. Pictured among others are Lee (Movsovitz) Rosenzweig Dor-Shav, Barbara Lubar, Terry Segall, Sylvia Kantsiper, Lynn Kantsiper, Barbara (Tenenbaum) Hacken, and Barbara Rosenberg.

DANCE RECITAL, 20 MAY 1958. From left to right are Carla Kramer, Elsa Brueck, Joyce Brown, Sharon (Birnbaum) Goldblatt, Marsha (Elman) Bernstein, and Charlotte (Lipsitz) Black.

J.E.A. HARD TIMES CANTEEN, 18 JANUARY 1958. From left to right are Samuel Sutker, Howard Ginsberg, Sydney (Solomon) Ratner, Iris (Diemar) Ginsberg, Robert Segall, and William Alpert.

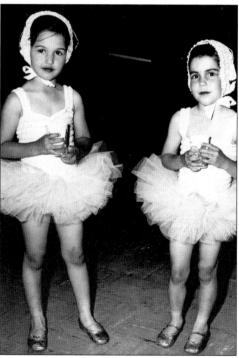

DANCE RECITAL, 20 MAY 1958. Sandra Haysman is shown on the left with Marsha Pike on the right.

SURNAME INDEX